Collage

Elizabeth Ashurst

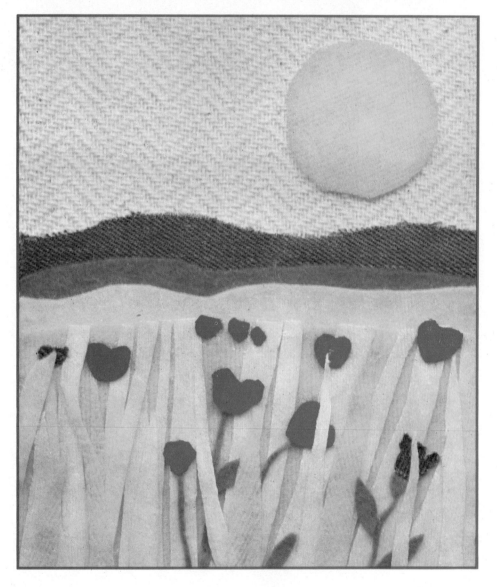

Marshall Cavendish
London and New York

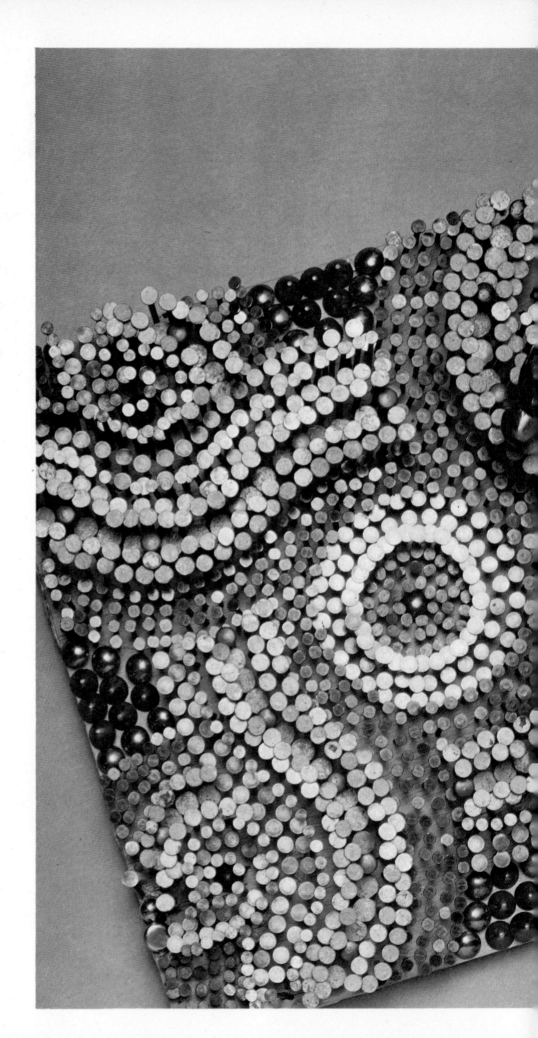

Edited by Linda Doeser

Published by Marshall Cavendish
Publications Limited.
58 Old Compton Street
London W1V 5PA

© Marshall Cavendish Publications
Limited 1976

First Printing 1976

ISBN 0 85685 160 4

Printed in Great Britain by
Severn Valley Press Limited

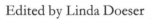

About Collage

Everyone gets pleasure and satisfaction out of creating something uniquely personal and collage is the ideal medium. You need no special training or talents—just the desire to create something original and the courage to give full rein to your self-expression. In fact, it is a perfect medium for everyone from young children bored during long school holidays to adults looking for a relaxing hobby at weekends. Any member of the family, or indeed the whole family together, can do it.

The only 'special' equipment you will require is some glue. Collages can be made from anything and everything— old letters, scraps of fabric, nails, pieces of string, ring pulls from cans, dried flowers—whatever you have to hand. You will find yourself looking at familiar objects with new eyes and will become an avid collector of bits and pieces.

Collage is a unique means of self-expression because of its endless scope. You can work in two or three dimensions, make pictures or mobiles, be realistic or abstract—whatever takes your fancy. Every work is new, exciting, different and completely your own. *Collage* does not *tell* you what to do—it is a guide to this exciting craft. Each chapter deals with a specific type of collage—yarns and fibres, metal, fabric—and gives you information about the materials, hints on how to get the best out of them and some general comments on design. The suggestions for experiment at the end of each chapter and the many collages illustrated are not there for you to copy slavishly but to spark off your own ideas to create something uniquely your own.

Where there is variation, American names have been given in square brackets. For example, hessian [burlap].

Contents

Introduction

The term *collage* is derived from the French word *coller* meaning to stick. Numerous materials — photographs, paper, fabric, yarn—may be built up partly or wholly upon a base to form a picture or decoration. Essentially, it is an art form which makes use of the unwanted objects of our acquisitive society which discards as quickly as it consumes.

Collage is within reach of the youngest child and the oldest adult—age and experience are immaterial. Through creating in collage we may learn to look at our surroundings with a fresh eye, sharpen our senses and enjoy life more fully.

This book is not intended to be read from start to finish but to be used as interest dictates. The illustrations and suggestions for experiments are meant to inspire. They are not examples to be copied slavishly, for each person is unique and sees and expresses the world in his own particular way.

Many people have been brought up to believe that skill in portraying reality with pencil and paint is the sole criterion for judging creative expression. The myth that this is the only real medium through which we succeed or fail, still predominates. There are a number of other media, not least of all collage, accepted by many of the world's major artists such as Picasso, Braque and Matisse.

Collage as Folk Art

There must be many people who, at some time during their lives, have been possessed by the overwhelming, often illogical, desire to collect something. It usually begins at an early age with doting parents lovingly pasting our photographs in their albums. Later, past babyhood and into childhood, we are infected by this mania, triggered off, perhaps, one holiday when seashells, seaweed, pebbles and other bric-a-brac are surreptitiously stowed away in a laden suitcase as reminders of bygone joys.

By the time we have reached the age of eight or nine, the hunt is on—stamps, scrapbooks, silver paper, postcards, coins, pressed flowers—the collecting fever fluctuates according to fashion. Sometimes it evaporates, but often it continues in various guises well into adulthood.

Affluence appears to produce excessive waste, something frowned upon by our nineteenth century forefathers who considered thrift and industry major virtues. 'Waste not, want not' and other such sayings no doubt prompted the making of patchwork quilts and folding découpage screens. Hans Christian Andersen (1805–1875), quite apart from his writings, distinguished himself with scissors and paper and produced one of these screens, smothered with all manner of cut-outs from whatever had taken his fancy at home or abroad—sail boats, steam ships, people drift across the screen in a dream-like fantasy.

At the turn of the century there was a vogue for ashtrays adorned with cigar bands and glass trays with collages of exotic butterflies. One slightly eccentric German merchant produced a startling casket covered with an assortment of braids, buttons, hooks, corset stays and ladies' garters.

Valentines

The tradition of sending greetings cards to sweethearts and lovers on St Valentine's Day originates from the mid-eighteenth century, but the idea did not become commercially viable, in Britain at least, until the introduction of the penny post in 1840. From this date until 1870, the Valentine had its golden years. There were cards catering for all tastes from the sentimental to the slightly salacious. To begin with the cards had cupid's hearts, bows and arrows and love birds and later cards with mechanical movements became popular. These necessitated the pulling of a paper tag which would move the arms or legs of a figure or lift a skirt to show a tantalising glimpse of a lace-clad limb. As the years passed, publishers vied with each other in embellishing their products even more elegantly with net lace stamped out of paper, spun glass or gold filigree borders, locks of hair, beads, shells, tiny dressed dolls— every conceivable form of collage decoration was utilized to capture the whims of the public.

Paper Cuts

In Poland, at about the same time, the relatively new folk art of paper cutting

Detail of a mid-seventeenth century box in stump work. An assemblage of exquisite needlework, seed pearls and metal threads with padding and pleating.

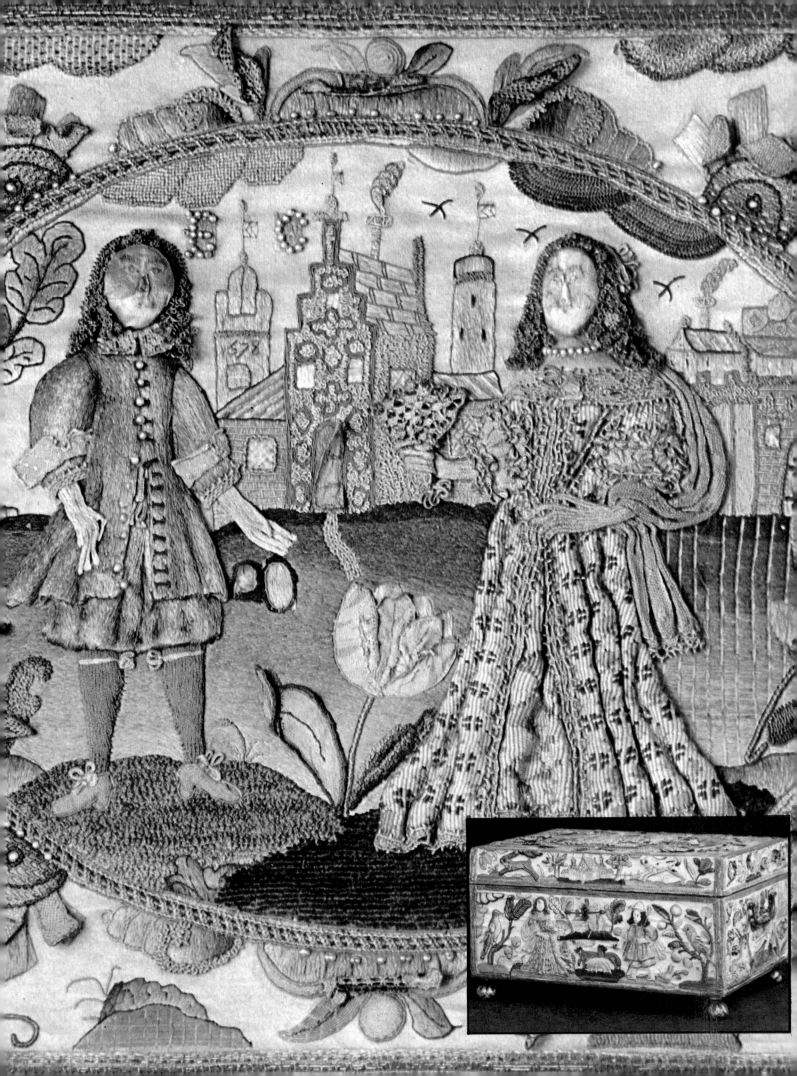

Above *A twentieth century popular Chinese paper-cut.*
Right *A busy twentieth century scene with geometric shapes provides a source for collage design.*

was developing. The early patterns were mainly silhouettes of one colour intended for wall decoration, but later several layers of multi-coloured papers were used. The designs, intricately cut out with sharp scissors, vary according to the region but circles, squares, flowers, trees, birds, animals, figures and festivals feature among the most popular motifs. Windows as well as walls were used for displaying these decorations and at the same time showed off the skills of the owner. It is interesting to note how closely these designs are allied to the other folk arts of embroidery and ceramics, for their inspiration was drawn directly from the paper cuts.

Further east, in northern China, the art of scissor cutting was also practised by the peasants. The designs were handed down from mother to daughter and elaborated upon, recording impressions of daily life in the village among birds, insects, flowers and crops and illustrating incidents from well-known stories. In some areas they are still used to decorate windows or the interiors of houses in the lunar New Year.

However, the pastime of collage was not unknown before the nineteenth century, for in 1686 the first handbook to teach the art of paper cut-out

silhouettes was published in Holland and the ladies of the upper classes eagerly took up the fashion. Genealogical registers of the seventeenth century also show, added to the entries of coats of arms and heraldic devices, pasted and painted pictures.

Perhaps the earliest examples of *papier collé* are to be found in Japan where, in the twelfth century, calligraphers began to copy poems on sheets pasted together from a number of irregularly shaped pieces of tinted paper. The whole composition was then sprinkled with tiny silver and gold cut-outs of birds, stars and flowers. The torn or cut edges of the papers were brushed with ink to represent rivers, mountains, hills and clouds.

Assemblage

The art of assemblage which includes all forms of composite art and modes of juxtaposition, denotes the fitting together of parts and pieces into collage form. An early example of this type, found in religious folk art, may be seen in Austrian and German churches of the rococo period, where mawkish glass fronted reliquaries displayed crammed shelves of richly decorated skulls adorned with lace, gemstones and the like.

In a similar manner, Russian icons show collages of various materials.

This was a development of the Byzantine art of earlier centuries when gems and pearls were used to adorn the Virgin's crown, surrounded by a halo of fine gold leaf often incised or in filigree. Metal mountings with floral arabesques, sometimes studded with precious stones, formed the rich borders.

The Twentieth Century

All these illustrations suggest that collage had its origins in folk art, but it was not until the early part of this century that the Cubists, led by Picasso and Braque, discovered its exciting possibilities when incorporated with painting. As a reaction to the Impressionists' preoccupation with light and colour, this group of artists sought to understand the nature of form. They 'analyzed' their subjects seen simultaneously from all angles, then, ignoring the rules of perspective and modelling, expressed these views together on the one canvas. By pasting everyday objects on to their paintings—newspaper, wood veneers, wallpaper, labels from bottles, cigarette cartons—they introduced a new element of realism into their disjointed treatment of the subject, whilst, at the same time, created illusions of recession and projection.

Sonia Delaunay (born 1885 in the Ukraine) was an early follower of Cubism. Her particular contribution was in the study of the effect of electric light upon colour. After the birth of her son in 1911, she made a many coloured blanket for his cradle from scraps of fabric. It seemed to her that these patchwork shapes, consisting mainly of squares and triangles, were sympathetic to those used in Cubism, so she used them as a base for many of her later paper and cloth collages, book bindings and dress designs.

Collage also played a part in the role of Futurism, an art movement which came into being in 1909, proclaiming the universal beauty of movement in

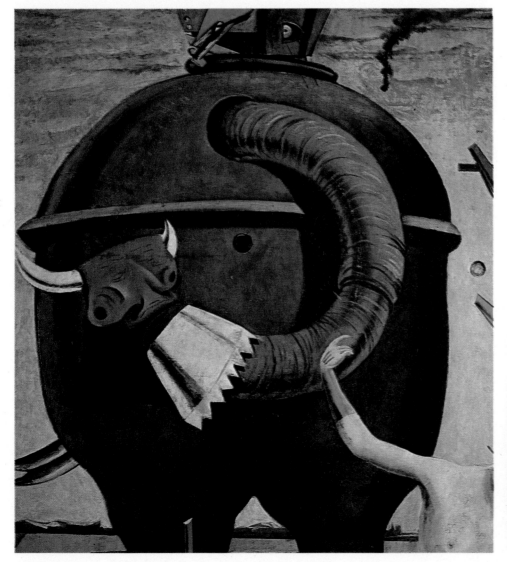

Left The Elephant Celebes *by the twentieth century artist Max Ernst. He took his imagery from the machine world to create his sometimes terrifying surrealist works.*
Below *An assemblage of a bicycle seat and handlebars to form a bull's head, created by Picasso.*

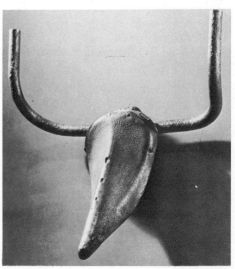

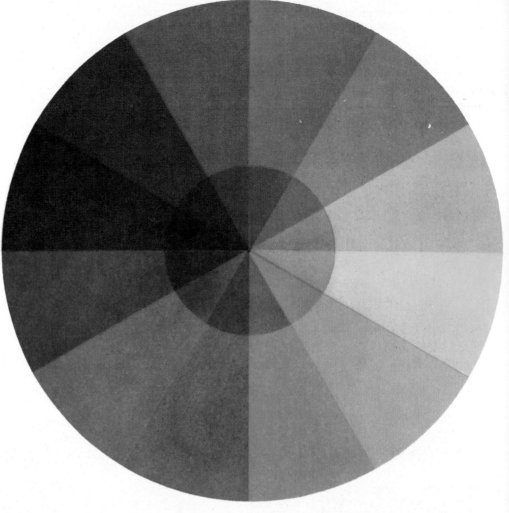

The pure hues of the spectrum in a colour wheel showing the tonal gradations from dark to light, the contrasting (opposite) and related (adjoining) colours.

the motor and machine. Its major artists were the Italians Boccioni, Balla, Severini, Carra, Russole, all of whom practised cutting and pasting.

As a reaction to the horrors of the First World War, Dada, a deliberately anti-art, anti-rational movement, was born, intended to shock, confuse and scandalize the bourgeois mind with the use of vulgar language, accident and contempt for venerated cultural standards. Although he was not closely established in the Berlin Dada circle, Kurt Schwitters (1887–1948) was one of the most prominent exponents of this movement. His world was the street, a pre-existent collage of juxtaposed images and surfaces from which he obsessively salvaged his materials—bus tickets, scraps of printed paper, labels, worn-out shoes, coins, nails, buttons— virtually anything which attracted his eye he combined with paint, balancing one material against another in his colourful and nostalgic collages, realistic representations of the history of his time.

Since then, the pendulum of fashion has swung between realism and abstraction, but the use of collage has remained constant. Matisse was in his sixties when he took up *papier découpé*, delighting in its precision and scope for the imagination. Using unpatterned papers in brilliant colours, he took on a new lease of creativity which culminated in the publication of a book of découpages entitled *Jazz*.

From the mid-50s onwards, in both the United States and Britain, new movements occurred. With what is now called 'Pop Art', everyday objects and the throw away scrap of industry were avidly collected and re-combined with a more obvious literary message. In the United States, Claes Oldenburg and Robert Rauschenberg, in Britain, the painter Richard Hamilton and sculptor Eduardo Paolozzi are representatives of these art movements.

Materials

For facility of working, details of equipment and materials are listed at the beginning of each chapter. Please remember that they should in no way be compartmentalized but will naturally overlap one with another according to need. No adhesive is infallible and although some types, such as PVA, are recommended more frequently than others, there are usually several alternatives.

Once you have become involved with collage there is bound to arise the problem of storage. However, the solution lies in the use of plastic bags and see-through containers for the smaller items, cigar and cardboard boxes for bulkier objects, with folders for paper, card and cut-outs.

Finally, a word to the impatient ones, apply all adhesive sparingly and carefully, allowing plenty of time for your collage to dry.

Design

For many people the very word 'design' has terrifying connotations. This probably has something to do with the way in which they have been taught in the past when the emphasis has been placed on the ability to portray realism with a pencil. There is little doubt that drawing is one of the best ways for sharpening our powers of observation and understanding of line but there are other aspects of design which are equally important in the choice of materials and their ultimate arrangement; for example, colour, tone, shape, texture and pattern blended with imagination, personal experiences and feelings.

If you are hoping to create reality of the day to day variety, collage is definitely *not* the medium for you; better by far to invest in a camera or a set of oil paints and brushes. Collage is often fantastic, created from existing materials.

Colour

Colour is contained in light and it is in a rainbow that we can observe nature's seven pure hues — violet, indigo, blue, yellow, green, orange and red—as they fuse one into the other to make up the spectrum. If this phenomenon is seen in a natural setting, it is interesting to note that the colours harmonize perfectly unlike in an urban environment, where purity seems almost out of place. For this reason, you

are far more likely to achieve a success-
ful colour scheme with natural objects.
In man-made surroundings colour is
constantly heightened to catch the eye
and brighten the drabness of steel and
concrete whilst at the same time
reflecting an artificial way of life out of
tune with nature. This fundamental
difference between natural and man-
made colour is evident in all collage
materials and their choice will reflect
your attitudes and environment.

Tone

Tone is closely related to colour and
implies its comparative lightness or
darkness. For example, a pure hue such
as blue may be seen in a variety of tones
ranging from the palest blue to the
darkest blue-black. Exploring this
simple variation either in a hue or
neutral grey is a good starting point for
any collage and one which has been
suggested in several chapters.

Further tonal gradations may also be
seen within the spectrum where yellow,
as the brightest hue, tends to project,
whilst violet, as the darkest, recedes.
You may prove this optical illusion for
yourself by taking two small pieces of
paper or fabric in yellow and dark blue
and placing them on a violet back-
ground. The shape of the yellow piece
will appear clearly defined but that of
the blue will be indistinct.

Apart from actually working with
collage materials and finding out
through experience how these 'illusions'
operate, looking with half closed eyes
at the tonal structures of famous
paintings and collages will help you to
understand this most fundamental
factor of design.

Shape

All collage materials have a shape of
some kind. Many are ready-made as in
the case of natural or kitchen objects
and part of the attraction of collage lies
in this feature which allows for a
direct approach with easy movement
and appreciation of the materials.

Shapes may be described as either
regular or symmetrical, or irregular or
asymetrical. Many man-made and
natural objects such as clock parts or
crystalline structures are symmetrical

*Tone is cleverly used in this nineteenth
century patchwork quilt to create the
effect of a three-dimensional surface with
one regular shape.*

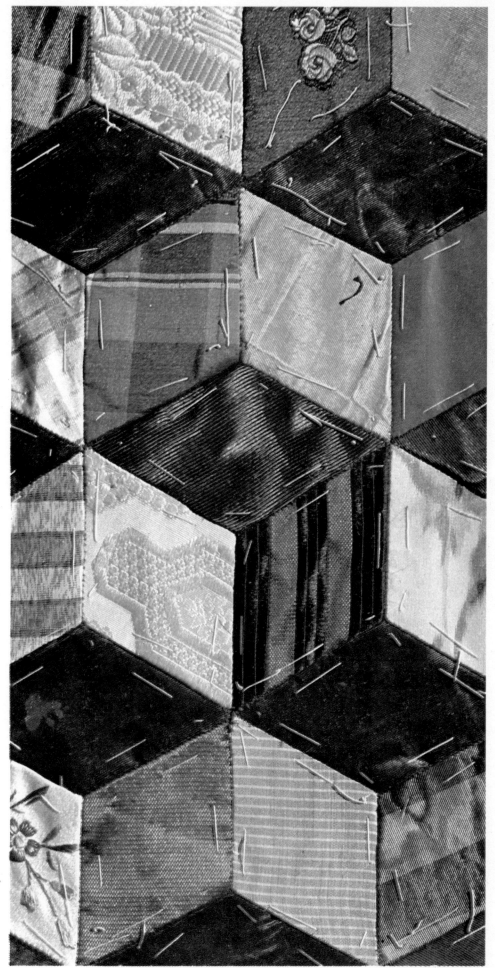

Above *A French box decorated with découpage flowers and figures. Irregular shapes are used to create a formal, symmetrical design.*

Below *Paper collage by Matisse. Coloured paper is cut into simple, almost geometrical shapes and arranged with deceptive ease. Note the negative shapes.*

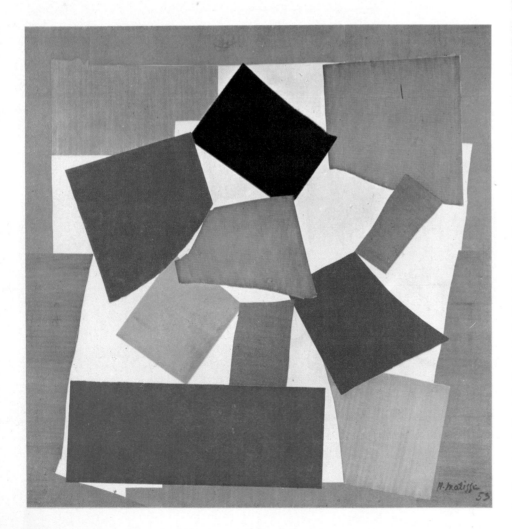

in design, that is, both halves correspond exactly and therefore balance. Generally speaking, most people find it easier to work with symmetrical shapes which are often geometric in origin, for in a sense, the balance has already been decided in the perfection and simplicity. For this reason, many of the suggestions for experiment come within this category.

Asymetrical shapes are less formal in appearance and usually you will find plenty of them in your collection of scrap fabrics and papers. They offer many more permutations of arrangement but require greater care in balancing the heavier with the lighter shapes.

Within each group of collage materials there is a vast choice of shapes which can often be bewildering to the beginner. A random selection of these arranged in an arbitrary manner will often produce disappointing results because there is little or no relationship between the shapes. Look at any well-known painting, collage or sculpture and you will see that one or several shapes perpetuate themselves throughout in various forms and lines. This partly accounts for its successful composition. Similarly it is a good plan when creating with collage to limit yourself to shapes which have a 'family resemblance' of some kind such as curves or right angles. These may be distorted and varied in size but they will help to give your work unity without monotony.

As in every aspect of design, contrast is an important element and may become a visual focus in a composition of related shapes. Examples of this kind of contrast are all around us: poplar trees set in a patchwork of fields, apples dangling from leafy foliage. Contrast has many forms; it may only be a slight variation in its surroundings such as the smoothing of an angular shape or it could be a complete change such as the introduction of a square within a pattern of circles. Either way, it should be remembered that any type of visual contrast is better introduced slightly off centre to the compostion unless the design is deliberately symmetrical.

Many beginners, engrossed by the shape which they want to apply, totally ignore the background area, forgetting

that their collaged materials have created further shapes. This negative area is an integral part of the whole design and it is important that it should relate 'comfortably' to the applied shapes. When starting a collage it is easier to arrange first the larger, then the smaller shapes. In an asymetrical design, balancing one larger shape with another or several smaller shapes takes time in experimentation, the only guide to the solution being a feeling of 'rightness' of arrangement.

Line

Developing an awareness of the qualities of line will assist you to express your ideas more clearly. There are linear elements which appear in many variations in our surroundings: scaffolding, ripples on the sea, grasses, telegraph wires, and so on. Viewed individually each example has an expressive quality; scaffolding suggesting stability, ripples, calmness and tranquility, grasses, growth, and converging telegraph wires movement.

Seeds, pasta, buttons and sequins may be thought of as dots, the precursors of the line, which, when arranged end to end form lines showing rhythm and direction. Similarly yarn, wire, matchsticks and growing things clearly show this particular characteristic and may be used to describe a shape or form a pattern. These materials could be thought of as a substitute for the drawn line and one which many people find easier.

Texture

Although texture may be seen purely visually it is essentially concerned with the sense of touch. For this reason it is very personal, with no two people reacting in the same way to a surface for it will have different associations for each.

Some collage materials are particularly tactile such as fabric, paper or yarn, and have a strongly magnetic quality for all ages. In many instances the texture will suggest the subject, for example, filmy organza for water, shining coloured foil for something theatrical, coarse string for tree bark. This aspect of suggestion should be utilized whenever possible. Apart from developing a feeling for the materials it will allow full scope for the imagination.

Many objects of similar textures such as sand in a variety of colours, may be amalgamated in a collage, but juxtaposition of one differing surface with another, fur with velvet or seeds with dried tea leaves, will give vitality to the design.

If you become interested in creating nuances of texture, there is much to recommend a limitation to one colour such as white, so that maximum emphasis may be placed on the interplay of light and shade upon the surface.

Pattern

Visual pattern may be described as an arrangement of shapes or lines which may be two or three dimensional. Although pattern may have a tactile surface such as the feathers of a peacock, it differs from texture in that the shapes or lines are more clearly defined.

In nearly all types of pattern there is an element of repetition and we may discover this in both natural and man-made forms, for example the stripes on a zebra, cells of a honeycomb, spokes in a bicycle wheel, brickwork and Persian carpets.

Photographs, pictures and drawings of such patterns will suggest many ideas for the arrangement of collage materials. Alternatively, separate units such as pasta, curtain rings, pressed leaves and matchsticks may be built up directly into patterns. Geometric shapes are always a good source of design as they are in themselves, perfect forms. Paper cuts, prints from waste materials and potatoes, ink blots, dribbled paint, wax rubbings offer further possibilities.

Sources of design surround us—magnified surfaces may suggest linear patterns, colour schemes or shapes as a starting point for collage. The picture on the left is a close-up of a shattered windshield, on the right is a cross-section of a cabbage.

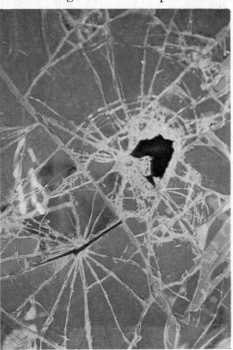

Yarns & fibres

The Huichol Indians of the Mexican Sierra Madre are considered to be the only major aboriginal group north of the Amazon to have survived with their tribal structure, traditions, religion and arts intact.

Apart from producing elaborate embroidery and objects made from feathers and beads, they show remarkable skill in the creation of *nearikas,* or wool and beeswax paintings. These have been used since the earliest times as woven offerings to the gods on important occasions, such as the birth of a child, but some of the most imaginative examples are produced during the fiesta following the great peyote pilgrimage. The eating of the peyote cactus is a feature of the Huichol religion and the absorbing of its 'divine', halluncinatory properties is the inspiration for the designs.

Below *Look at the many different ways of manipulating yarn which are used in this panel.*
Right *Combining yarn with fabric gives contrast and adds vitality.*

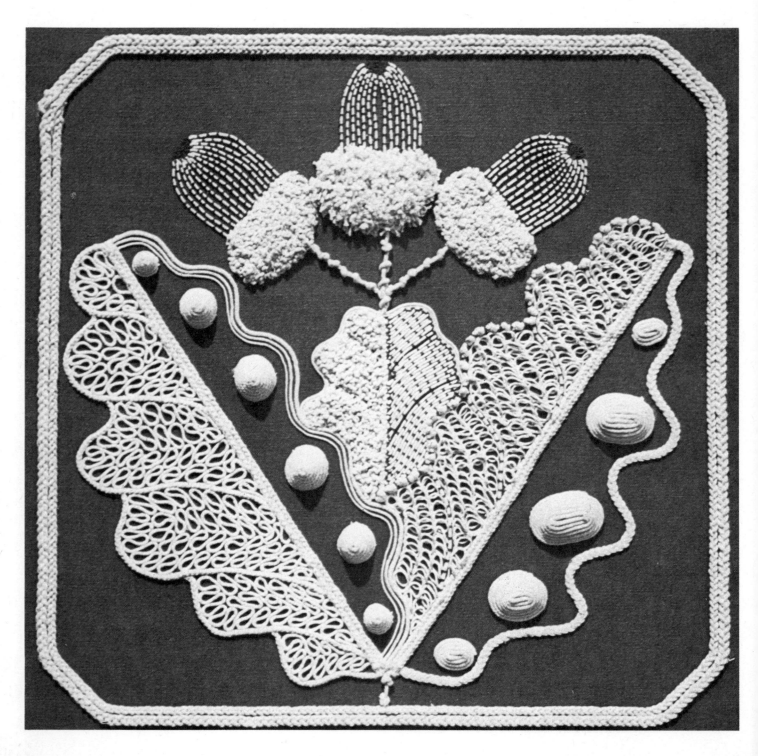

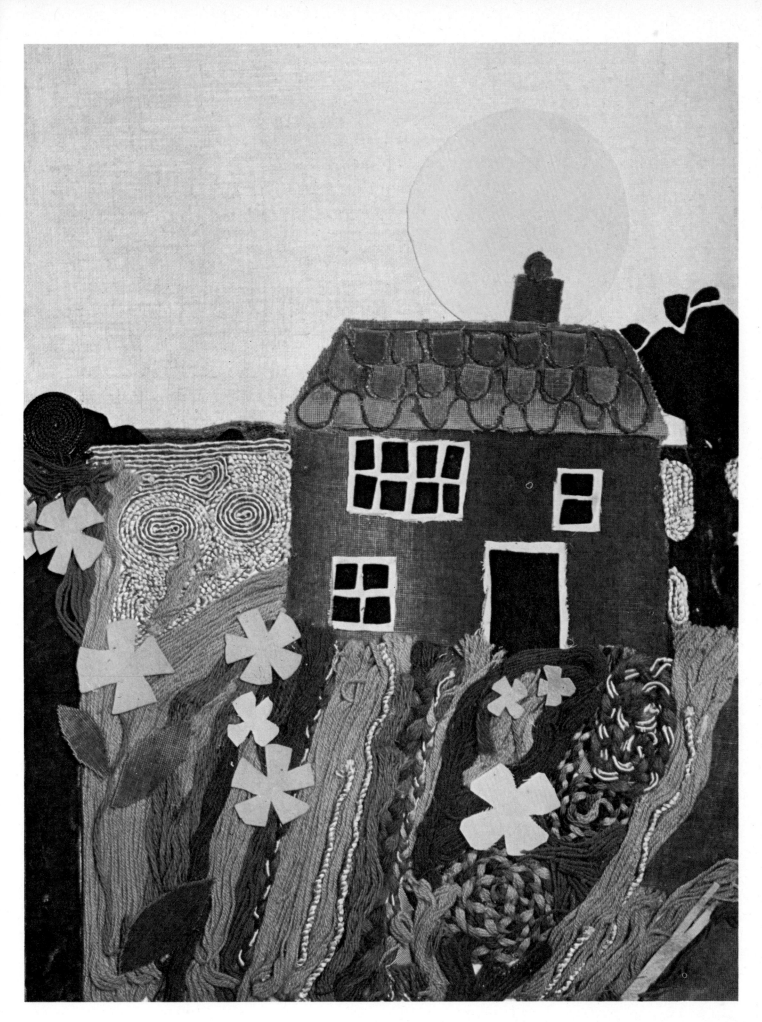

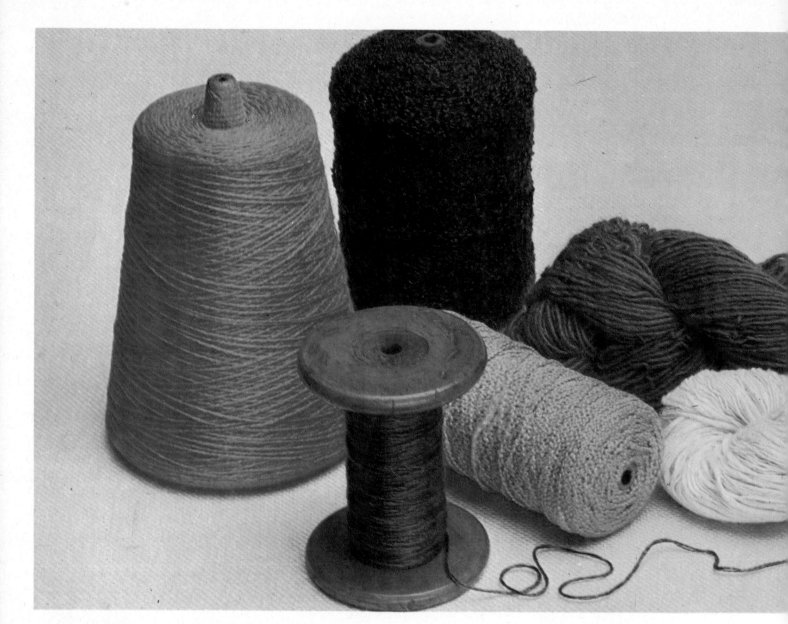

Each swirling layer of brilliantly coloured wool is pressed into a layer of beeswax set on a wooden base, and the designs are considered so sacred that strangers are not permitted to watch their creation.

Apart from the peyote cactus, the materials for this form of collage are readily available in a wide selection of yarns from natural to man-made. The vision may be different but the pleasure derived from creating will be the same.

Materials
Natural—various threads including chenille, linen, thin string, cotton [thread] in various plys, tarred string, twine, wool of all types, piping cord, jute, hemp, sisal, raffia rope, unspun wool, hemp, jute and cotton. Man-made—nylon, plastic, polypropylene, cellophane, gift yard, plastic tubing, fibreglass.

Base
White, brown or coloured thick paper, cardboard, hardboard, chipboard [paperboard], hessian [burlap] plain and paperbacked (this could later be mounted on to hardboard or chipboard [paperboard]), sacking, coarse linen.

Equipment
Scissors, tweezers for moving small pieces, sharp craft knife and cutting board, plastic spreader or glue brush, several weights for helping springy yarn to adhere during the drying process, dressmakers' pins, newspaper for working surface.

Adhesive
White PVA.

Design
These materials are essentially linear. For this reason, they offer an excellent alternative to drawing, with the advantage that they can be moved around the

Above *Some examples of natural and man-made yarns showing variety in thickness and texture.*
Right *A wall hanging made from yarns on a hessian [burlap] base.*
Far right *This picture shows the textural and pattern-making qualities of yarns, such as sisal, hemp and thin white string, using a limited range of colour.*

glued surface until the desired arrangement has been reached. Doodles and rhythmical patterns, solid shapes based on both abstract and realistic designs offer plenty of scope for working, as well as a good introduction to embroidery and weaving.

Before attempting anything on a large scale, a little time should be spent on exploring the creative potential of the materials, otherwise your work could look rather flat and lifeless. Try the

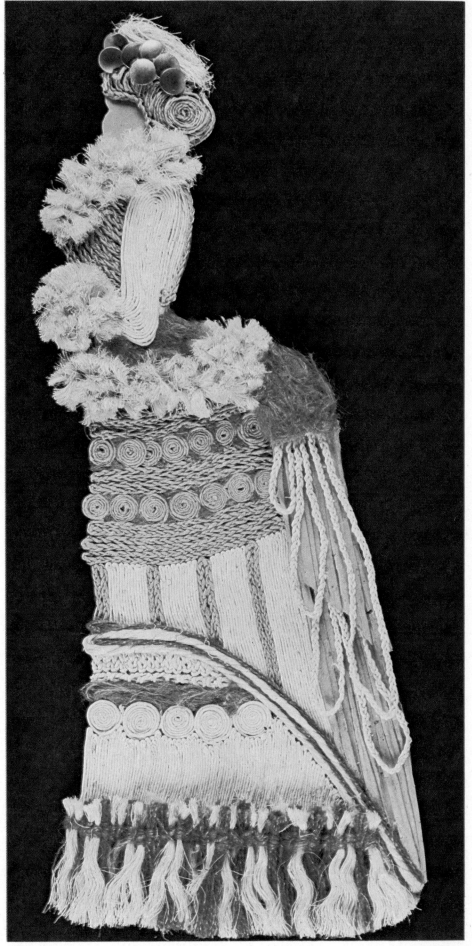

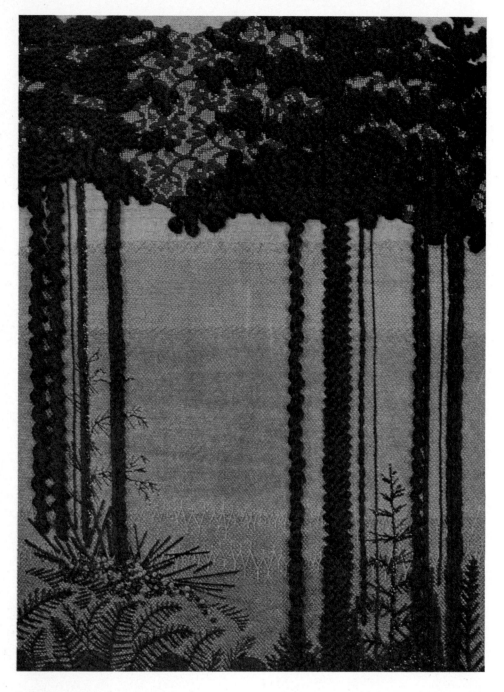

2 Now fill in your landscape with some of your sample yarns, plaits [braids], knits etc., combined with other plain ones. Imagine it as an aerial view and aim for contrasts in texture and thickness of line. Note: weights will hold down springy yarns which will not stick firmly.

Wall hanging

1 Cut a piece of hessian [burlap] or sacking not less than 30cm (12in) wide and 45cm (18in) long. Select your yarns, which could either match the background fabric or contrast with it.

2 Leaving about 8cm (3in) space at the top of the rectangle, withdraw bands of thread in varying depths, but leave some plain hessian [burlap] for contrast. Aim for variety of proportion in the depths of the bands you create.

3 Using the withdrawn ends of your yarns, re–group some of the vertical threads in your bands by tying, weaving, etc., and you will begin to form a pattern. Once again, some lines could be left plain.

4 A few intervening spaces can now be filled with the rest of your yarns, which could be stuck down in rhythmic lines and shapes.

5 The bottom of the hanging could be simply fringed by withdrawing further threads and enriched, if you wish, by adding beads or seeds in matching colours to act as decorative small weights.

6 Finish your hanging by turning over the top to make a hem which can be pinned and then stitched down with small running stitches, using one of the withdrawn threads. Run a bamboo cane or a piece of dowelling through the hem.

This hanging could also look very effective made on a larger scale.

Juicy fruit panel

1 Select one fruit such as an apple, pear, tomato, orange or pomegranate. Feel the texture of its skin and look carefully at its shape. Is it a perfect sphere, or has it flattened or raised areas? Cut it in half longitudinally or horizontally. Observe the smaller shapes which fit snugly inside.

2 Choose your yarns and background fabric or base. These should be varied in

following experiment:

1 Take about six lengths of different yarns of varying fibres and thicknesses, in natural colours—white, fawns and browns.

2 Feel their textures. Are they rough, smooth, matt or shiny? Are they pliable or springy?

3 Now try to alter the appearance of each length in some way. For example, try partially unravelling, knotting, looping and so on.

Further explorations could involve the use of more than one technique. Small, practice samplers could later be incorporated into a future work. These could show twisting to make a cord, plaiting [braiding] with three, four or more lengths, binding several lengths together to make one thick cord, crochet, knitting with large and small needles, weaving on a small piece of card.

Suggestions for experiment

Taking a line for a walk

Paul Klee, the twentieth century Swiss artist, used this approach in some of his drawings, in order to explore the spontaneous, simple and varied quality of line.

1 Cut one fairly long length of natural yarn and, beginning at the edge of one side of your base, 'walk' your yarn on to the edge of another side. The resulting path might be meandering, slightly curved or almost straight. Glue down.

texture and have some kind of unifying colour scheme. For example, all natural colours, or a range of tones from light to dark in one colour, or two or three which blend well, that is, those found next to one another in the colour spectrum, such as yellow, orange and red. The background could blend with the yarns or contrast with them.

3 Outline your shape with yarn, so that it fills about three-quarters of your background area. Glue it down.

4 Next, outline the small inside shapes and finally, the smallest shapes.

5 Having decided on your basic lines, you can now go ahead and fill in the remaining areas inside, with a variety of thicknesses of yarns, with some knotted, coiled, cut into tiny pieces and so on. The background area will probably look better if it is left free, so that the simple silhouette of the fruit will stand out clearly in contrast.

Further ideas could be carried out in a similar manner using one or several geometric shapes, a bird, fish, animal or butterfly, a face or mask, full or in profile, or combined, a hand, an eye and so on. You may also wish to incorporate

seeds and pasta with your yarns and fibres, for these will give added texture and richness to your final designs.

Above *A modern interpretation of the ancient Mexican technique of 'painting' with yarn.*
Below *A genuine Mexican wall painting shows great simplicity of design within a relationship of similar shapes.*

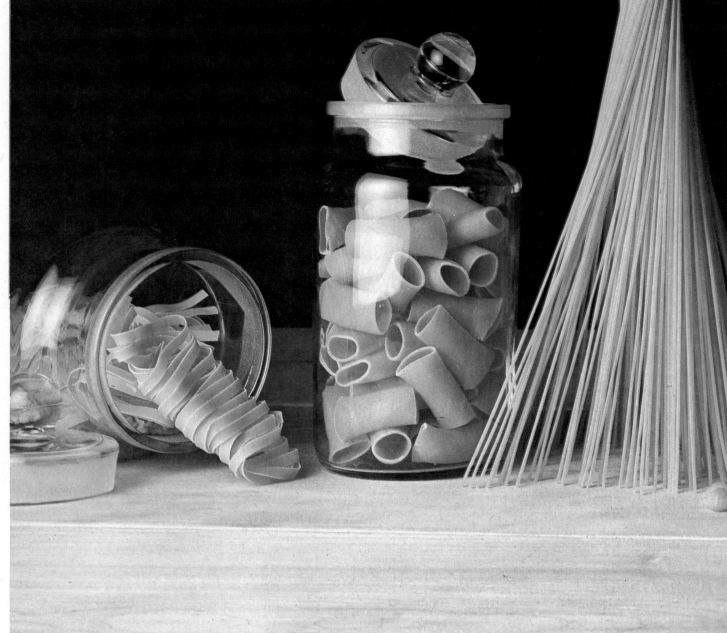

Pasta & seeds

Pasta and seeds have certain similarities with *tesserae*, the small stones, pieces of glass or bits of marble which were used in mosaics from the earliest times up to about the thirteenth century. Greek, Roman and Byzantine buildings are particularly famed for this beautiful and durable form of decoration and many of the designs could serve as inspiration for us today.

In other parts of the world, such as the Bushongo region of Africa, South America and New Guinea, primitive tribes have used seeds in combination with other materials, like shells and fibres, to embellish masks and shields.

Today we can still derive pleasure from this form of art and fortunately the majority of the materials are readily available from grocery, continental and pet stores. Seeds can be collected from fruit and flowers in the home and garden, but it is important that they are thoroughly dried before use, either in the sun or in a slow oven, otherwise mould and discoloration occur.

Materials

Warning—pasta is a favourite meal for mice and rats. Keep materials stored in lidded containers and unfinished work in a sealed, plastic bag.

Pasta—macaroni, spaghetti, zite, torti-glioni, conquilli, farfalle, etc.

Beans—haricot, coffee, runner, broad

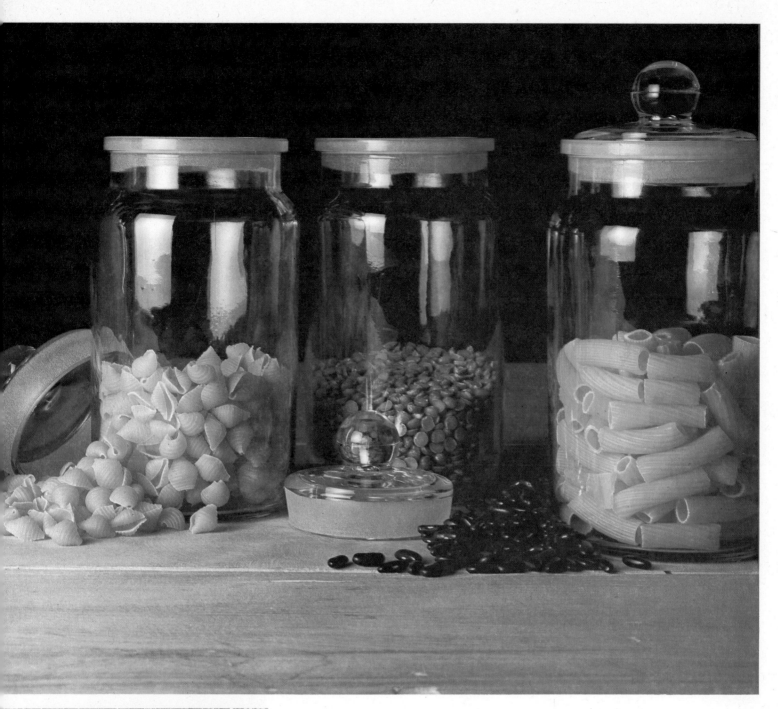

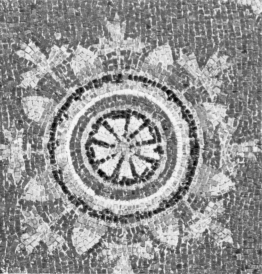

Above *Your kitchen shelf could provide some of the raw materials for this form of collage with the interesting shapes of various pasta and seeds.*
Left *A detail of a delightful sixth century Ravenna mosaic.*

[lima], french.
Seeds—melon, caraway, grass, canary, sunflower, pumpkin, orange, lemon, grapefruit, apple, plum, cherry.
Pearl barley, peppercorns, lentils, dried peas, rice.

Base
Chipboard [paperboard], hardboard, cardboard, one side of a packing case, trimmed to size, strawboard [insulating board], polystyrene tile.

Equipment
Clear glass or plastic jars for storage, tweezers for handling small seeds, orange sticks or toothpicks for moving pasta and seeds about on the base, newspaper for a working surface, plastic spreader for the glue, aerosol gloss varnish, not polyurethane.

Adhesive
PVA, contact adhesive.

Design
Apart from using the elongated forms of macaroni and spaghetti, you will be working principally with large and small dots in a variety of shapes. For this reason, the materials lend themselves

especially well to surface decoration rather than the portrayal of realistic scenes. Geometric forms and patterns are always good starting points for design and later, the linear qualities of natural objects such as wood contours, feathers, pebbles and microscopic sections of animal and vegetable tissues, can be explored.

Children always enjoy making masks and faces in caricature and natural materials are ideally suited to these. Fantastic castles, houses and birds can also provide further ideas.

Before beginning a collage, cover your entire working surface with a couple of layers of newspaper and place on it a plain 15cm (6in) square of paper for each type of seed and pasta. These may then be graded into tones ranging from white to dark brown and black. This method will enable you to select your materials at a glance, and is time-saving during clearing up as any surplus can easily be tipped back into the storage jars.

For bold and simple shapes, mark out your design with a crayon or a felt tip pen. The main outlines can then be followed easily before filling in the inside area. Some blank spaces can be left for contrast.

Both seeds and pasta in their natural state are subtly beautiful in colouring. For this reason they look best when left untouched, but if you wish, a glossy varnish may be sprayed over the work after completion. This will give greater depth to the colours and enhance the general appearance. Coloured or metallic lacquers may be sprayed on if a more textured or patterned result is desired.

Suggestions for experiment
A radial pattern

1 Select a square base and mark the centre with a dot.

2 Beginning from this point, work outwards, arranging and gluing your pasta and seeds in a symmetrical pattern. Aim for contrasts in tone and variety of

Right A radial pattern using various types of pasta, which has been given a final spray of red paint to emphasize its relief quality.
Below left Design based on a bark rubbing where the main lines have been translated into seeds, pasta and string.
Below right Detail of a larger spiral pattern composed of pasta and then sprayed with gold lacquer.
Below far right A spontaneous random design where the flat shapes of pasta contrast well with the dot-like masses and lines of the seeds. Brown sugar has also been added for further variety.

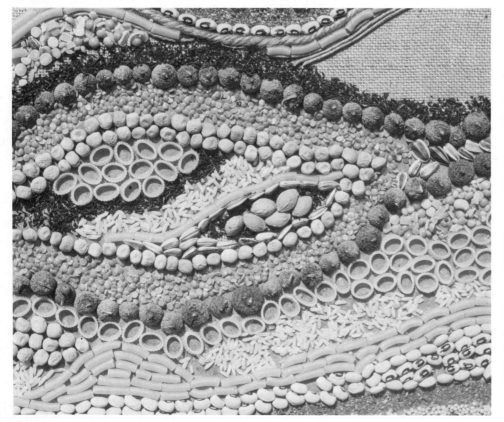

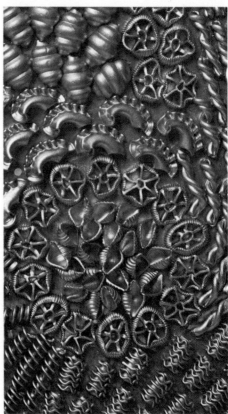

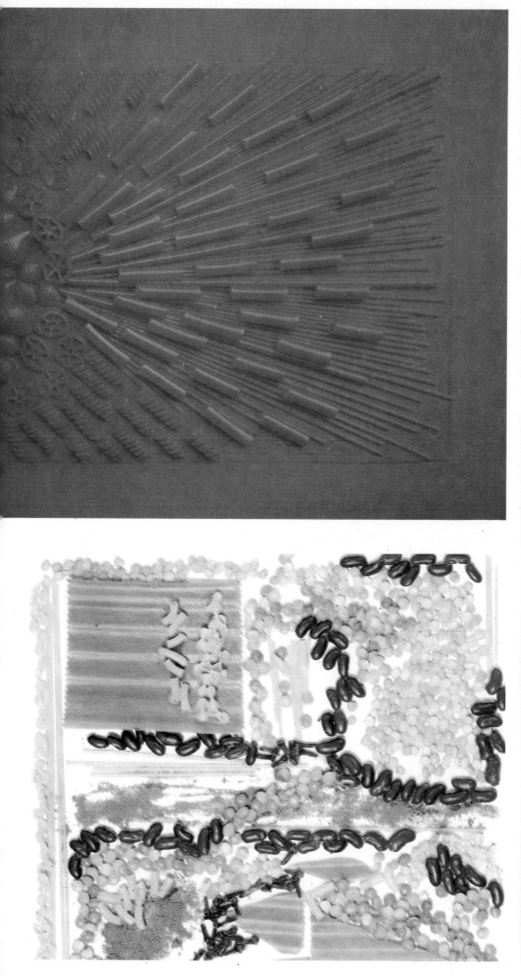

Above *Conquilli* Below *tortiglioni*

Above *ruote de carro*, Below *farfalle*

Below *cresto di gallo*

Coalhole covers offer many varied designs for the city-dweller and taking a rubbing is child's play providing you remember to stick your paper firmly to the surface with masking tape to prevent it shifting, otherwise the detail will blur.

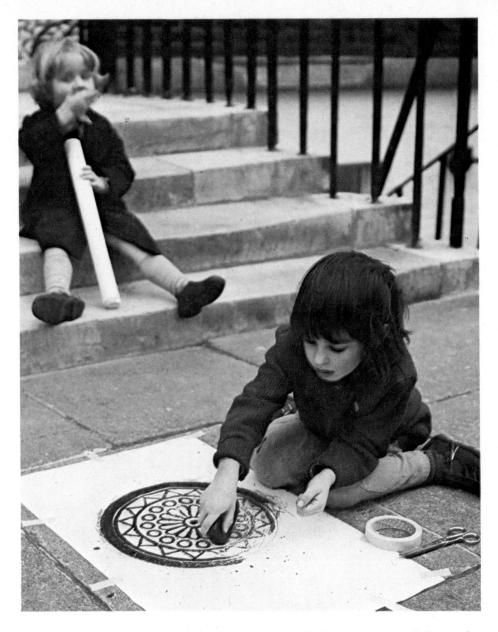

proportion in the contours. Spaghetti lengths are ideal for spokes and contrast well with circular pasta.

3 The total square may be filled with concentric lines or the circle may be left as a simple silhouette on a plain base.

Further experiments on this theme could be more complex in design, in which case, the pattern should be marked out on the base before gluing. A square or star-shape could be treated in a similar manner. There are numerous examples of this form of design if we look at our surroundings—the spokes of a bicycle wheel, clock parts, spiders' webs, daisy flower beads, kaleidoscope patterns and so on.

Free pattern

1 Spread the glue on your base in one of the following ways:

 (a) cover the entire surface area
 (b) cover parts of the surface area
 (c) dribble over parts of the surface area
 (d) make a thin cardboard stencil of a regular or irregular shape, place on your base and draw round it. Use this to build up the main lines of your pattern.

2 Sprinkle and arrange your chosen seeds and pasta on the glued areas, aiming for contrasts in tone and texture. Some parts may be built up into a relief by gluing the materials in layers.

3 When complete and the adhesive is quite dry, shake the surplus on to newspaper.

A pattern from nature

Tree bark and wood graining with their contrasting, rich, textural surfaces offer further opportunities for linear design which can be transposed into dots with seeds and pasta and further enriched in the intervening areas.

1 Make a rubbing of the area of bark or wood grain which attracts you. For this, a sheet of greaseproof [waxed] or shelf lining paper is required and a black crayon or piece of cobbler's heelball (also used for brass rubbing). Hold your sheet of paper firmly and gently rub the crayon in one direction over the surface until the underlying pattern clearly emerges.

2 Look carefully at your completed rubbing and note the main lines. Emphasize them further, if necessary, with additional crayoned lines.

3 You may feel that there are too many lines. If so, some detail must be eliminated. A simple method can be used, similar to selecting a subject with the lens of a camera. Take a sheet of plain paper and cut out a central square or rectangle, according to the shape of your base. Use this as your 'lens' as you move it about over the surface of your rubbing.

4 When you have selected your best composition, transpose the main lines on to your base using a wax crayon. Glue down your pasta and seeds.

Sprayed white, pasta may be given a lace-like quality. Border designs, such as this, could be used to frame a mirror or a simple picture.

Growing things

Our sixteenth century forefathers were possibly the first to be interested in the diversity of natural form. They expressed this in their gardens, embroideries and illustrated herbals. Later, the inveterate collectors of the nineteenth century demonstrated their affinity with nature by their craze for pressed seaweeds and flowers as an educational, picture-making pastime.

The desire to capture this ephemeral world remains with us and fortunately the materials are still there for the taking —in moderation. Admittedly, country dwellers and those on the fringe of open spaces are at an advantage, but even the most densely built-up areas of our cities support their own particular plant kingdoms ready for discovery by those who keep their eyes open.

If you are fortunate in having a garden, you need look no further, but you may miss a wealth of wild flowers and grasses in the hedgerows and by the sides of roads. These plants are often given the undistinguished label of 'weeds', but they have a simple, if unflamboyant, beauty of their own, offering an endless variety of form for the creative mind.

Collecting these materials is a joyful activity, for quite apart from the pleasure of being out in the open air, it develops an awareness of colour, shape and line through the slowly changing seasons of growth and decay.

Materials

This is only a guide and by no means

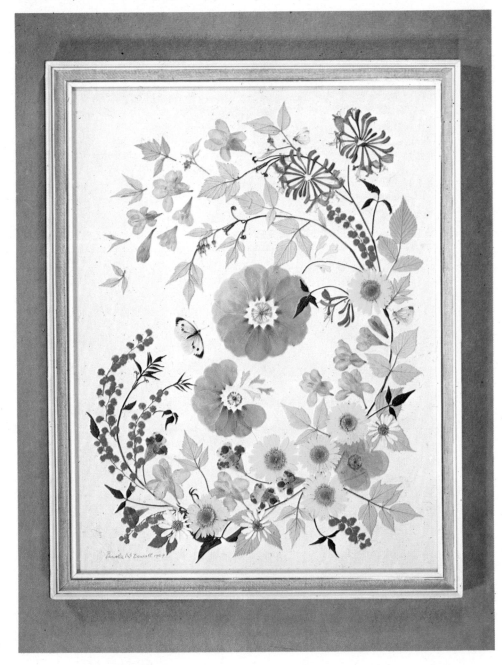

Right *The slightly faded colours of these pressed plants give this collage a subtle and satisfying colour scheme. Note how the linear stems contrast with the circular shapes and give a sense of flowing movement.*
Far right *Dried wild flowers make this eye-catching collage. The board has been mounted with framed glass to give an unusual window effect.*

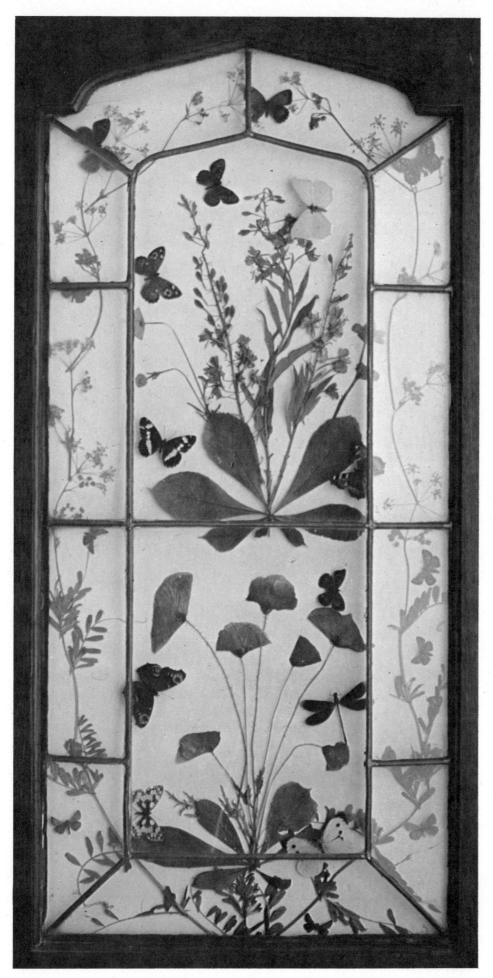

comprehensive.

Flowers and leaves, spring—bluebell, broom, celandine, coltsfoot, cowslip, daisy, dandelion, dog's mercury, fumitory, herb Robert, mallow, primula, shepherd's purse, stitchwort, violet, white dead nettle, wood anemone.

Flowers and leaves, summer—agrimony, buttercup, clematis, clover, cosmos, dog daisy, delphinium, equisetum, honeysuckle, ladies' bedstraw, lily of the valley, montbretia, pansy, poppy, rose petals, rosebay willowherb, vetch, viper's bugloss.

Flowers and leaves, autumn—blackberry, blueberry, golden rod, heather, hydrangea, marigold.

Berries and seeds, autumn—rosehips, haws, mountain ash, acorns, ash keys, sycamore, beechmasts, beech nuts, elm, lime.

Berries and seeds, winter—holly, honesty, larch cones, pine cones, walnut shells.

Leaves from trees and shrubs, spring—elder, elm hawthorn, horsechestnut, oak, lime, maple, rhododendron, silver birch, white beam, willow.

Leaves from trees and shrubs, autumn—laurel, prunus.

Leaves from trees and shrubs, winter—cypress, fir, ivy, spruce, skeletonized leaves of all types.

Base

Cardboard covered with black, white, coloured or metallic paper, mounting board, hardboard painted with acrylic paint.

Equipment

Blotting paper, scissors, tweezers, paintbrush to move flowers around, orange stick, toothpicks or the handle of paintbrush for gluing, several sheets of clean paper, heavy books for pressing.

Adhesive

PVA, quick-drying glue.

Design

The main characteristics of pressed plants are their shapes and lines. Colour is not a strong feature, but is subtle, consisting mainly of tones of cream, yellow, beige, rust and grey with sludgy browns and greens. Blue is a quickly fading colour in flowers, apart from delphiniums and viper's bugloss, and the rich pinks and reds of roses soon turn to creams and browns. It is therefore important to remember that many plants will fade, especially if placed in strong light, and so it might be a good

idea to choose a contrasting background for the mounting.

Finally, if you are displaying pressed plants, your results will be more attractive if you limit the number of shapes you use and leave some of the background free. Simplicity is the keynote.

Pressing leaves and flowers

If you want to create a dried flower and leaf collage, some planning in advance is necessary as you must allow six weeks or more for the pressing time.

To avoid mildew and wasted energy, it is advisable to pick your plants during dry weather, preferably not earlier than midday, to allow the bloom to have opened fully and the early morning dew to have dried off.

The picked flowers and leaves can then be arranged so that they do not touch each other, placed between two sheets of blotting paper and pressed in one of the following ways:

1 Between the pages of a large book, old telephone directory or layers of newspaper and additionally weighted with a heavy object such as a brick or book.

2 Underneath a non-slip rug or carpet which has constant wear.

3 In a flower press.

When your material has completed its pressing time, it should still be kept flat and stored between sheets of blotting paper in a book. Slips of paper could act as markers for indexing the plants by name, colour etc. At this stage, careful handling is needed as the plants tend to be brittle and crumble easily.

Spring twigs, bark and seeds

These should be thoroughly dried by leaving them in the sun or by tying them in bunches which should then be hung in a warm place. They can then be stored in lidded cardboard boxes or paper bags and classified by name, size or colour, if you wish. Plastic bags are not advisable as they could encourage mildew.

Mounting pressed material

Before starting work, ensure that there are no sudden currents of air likely to disturb your collage, or your attempts at design may be frustrated.

When you have decided on a satis-

Below *Flower presses are useful for holidays as they are easily transportable, otherwise, sheets of blotting paper or a large book will work equally well.*
Right *A delicate mobile can be made from pine cones and twigs, suspended by thread or nylon fishing line.*

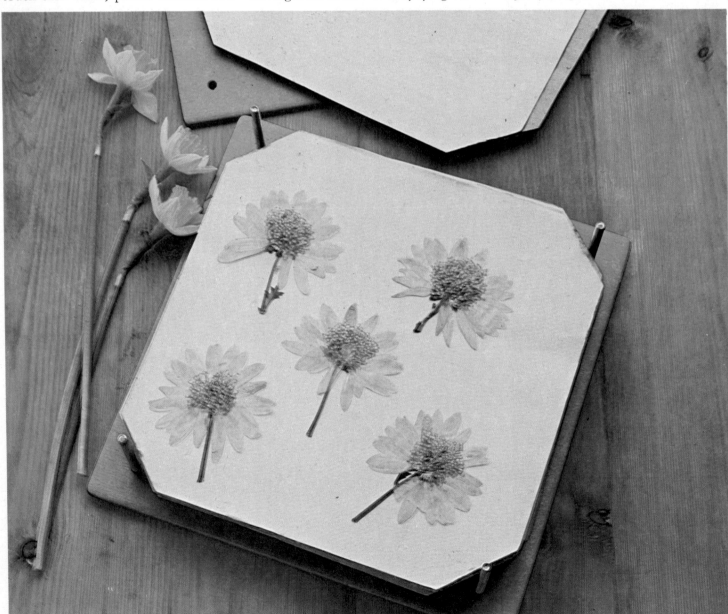

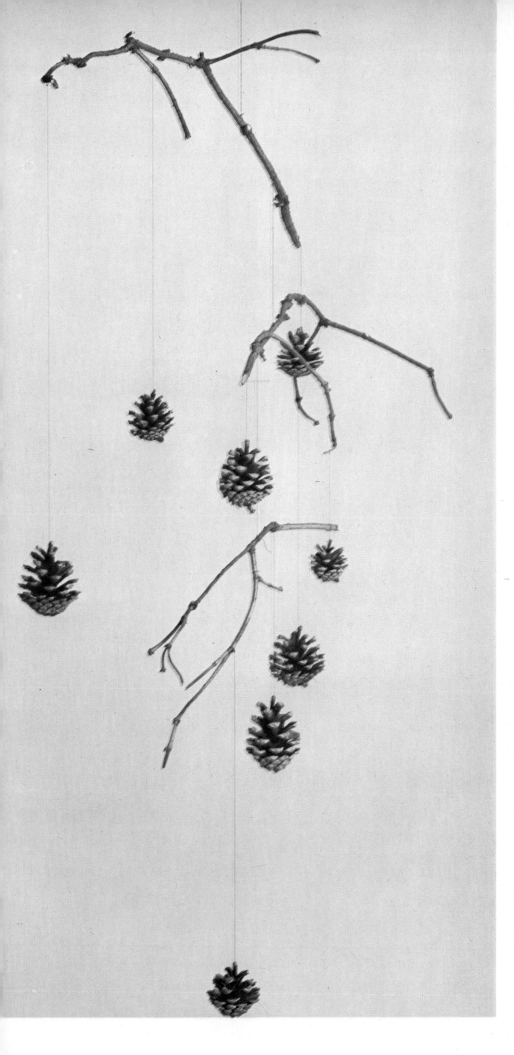

factory arrangement, glue each flower, petal or leaf, one at a time, gently lifting them on to a clean sheet of newspaper and applying the adhesive sparingly with the handle of a paintbrush, an orange stick or a toothpick. Cover the collage with a separate sheet of clean paper, not newspaper, and rub with your finger to press down thoroughly all the smaller and finer parts without damaging them. When gluing is complete, your collage will require some kind of protection from dust and curious fingers. This could take the form of glass, cut to the size of your finished picture, which should then be backed with hardboard, making a three-layered sandwich. Alternatively, clear, self-adhesive vinyl film may be used. This is relatively cheap, quick to apply and looks quite good, but care is needed during the mounting to avoid air bubbles and creases.

Suggestions for experiment
Patterns with pressed leaves, flowers and seaweeds
This is a good introduction and you could make an attractive chart for a kitchen, workroom or child's bedroom, or, on a smaller scale, greetings cards, pictures or book covers.
1 Leaves, grasses or seaweeds, in a variety of shapes and sizes, arranged in a vertical growing pattern and mounted on heavy card. Black, white or gold paper would make a good background.
2 Many flower heads of one type of plant, with or without leaves and stalks, mounted in a radial pattern. Daisies, pansies or marigolds could be used to good effect.
3 Flowers, leaves and grasses arranged in a symmetrical pattern radiating both horizontally and vertically.

Of course, there are many variations on these themes and other, less formal designs which you will want to create once you have become more familiar with the medium.
Mosaics with seeds and berries
Cardboard lids, cheese boxes and trays used for packaging meat, vegetables and fruit are ideal bases for this form of collage. As it does not require glue, it is very popular with children of all ages.
1 Fill your base with a stiff dough made from flour and water mixed with a teaspoon of salt to prevent mildew, or with clean earth or slightly damp sand.
2 Using the back of a spoon or a

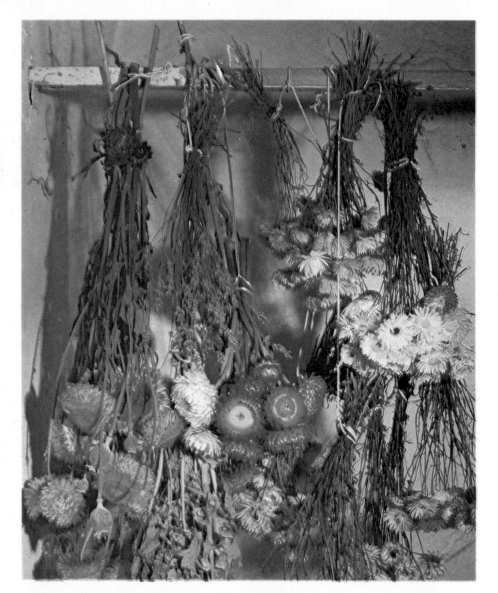

spatula, press the base firmly into the lid.

3 Starting from the centre, work outwards, pressing your seeds and berries into a radial pattern. Tiny pieces of twig and bark may be added, creating raised areas for contrast.

Flower gardens

The creating of a garden in an old plate or dish is one of the delights of childhood and is enjoyed equally by adults. It is yet another variation of collage and, although relatively short-lasting, can give much pleasure.

1 Fill your container with damp earth or sand, sculpturing contours for hills, valleys and lakes. Try your hand at landscape gardening in miniature.

2 You may add a covering of moss, pressed well down on to the base.

3 Now use your imagination and find ways to suggest lakes, footpaths, trees and grottos. Remember that scale is important, including the flowers. Otherwise the effect will look clumsy.

4 Finally, water your garden, taking care not to saturate it.

Left *Drying flowers and seed heads indoors, by hanging them in bunches.*
Below *Collage in a box—once pressed your plant material may be sorted into colours and stored in an empty box.*
Right *Small gifts may be made from your pressed and dried plants.*

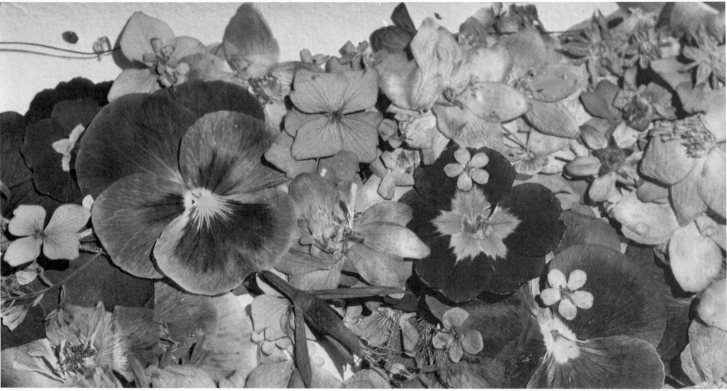

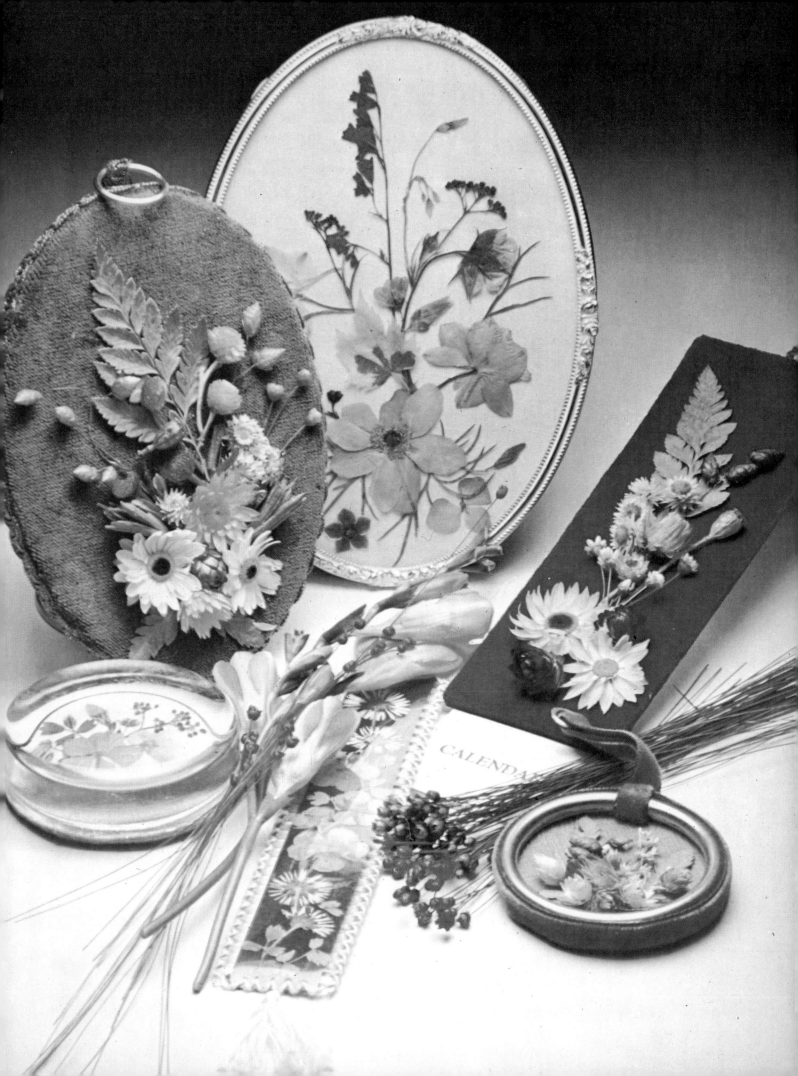

Paper

The word 'paper' is derived from 'papryus', a pithy reed from which the Egyptians made their writing materials. Today's method of manufacture, however, is based upon an invention made in China during the first century AD. Paper was produced from the inner bark of the mulberry tree by a process similar to that employed by the early Polynesians in the making of tapa, a non-woven cloth. Later, the Chinese improved their methods of production through the use of pulp made from twine, rope, rags and other fibrous materials. The wide selection of paper available today is the result of a slow refinement of processing with the relatively more recent additions of chemicals, dyes, wood pulp and machinery.

Although paper was originally intended for use as a writing material, by the beginning of this century Picasso and Braque were already seeing its possibilities as a fine art medium and employed it in their cubist *papiers collés*.

Another contemporary artist, Matisse, used a mixture of cut-outs in coloured paper with gouache and crayons and this helped to overcome the handicaps of age and illness during his last years. He called the process 'drawing with scissors'. From these simple pictorial elements he created anything from highly abstract transpositions to almost childlike reminiscences of folk tales, the circus or his travels. Quite apart from these innovators, other artists such as Kurt Schwitters, Max Ernst, Alberto Butti, Jean Dubuffet, Sonia Delaunay, Nicolas de Staël and Victor Vasarely, to name only a few, have employed *papier collé* as a means of expression.

Materials

Found—print from newspaper and telephone directories, typescript, old letters and envelopes, bills, grocery lists, cheque stubs, diaries, exercise books, road maps, music scores, graph, square and lined paper, magazines, brown, carbon, blotting and sand paper, paper bags, gift wrappings, ribbons and packing paper, wallpaper, corrugated card, wrappers from sweets [candies], gum, potato crisps [chips], cigarettes, Easter eggs and Christmas crackers, aluminium foil, confetti, paper napkins, plates and doilies, drinking straws, paint charts, used postage stamps, circulars, company statements, theatre, bus, rail tickets, theatre and concert

Collage as a mural decoration for a child's bedroom. This example includes scraps, cut-outs from Christmas and birthday cards, comics and wallpaper, stickers, wrapping and tissue paper.

programmes, playing cards, packing cases.

Bought—white and coloured tissue, white and coloured waxed paper, white and coloured cellophane, crepe paper, cartridge paper, shelf lining, sugar, pastel and blotting paper, card, coloured paper with sticky back, Japanese rice paper, plain and patterned, toilet and kitchen paper, self-adhesive labels in varied shapes.

Hand-decorated—brûlage (by scorching or burning), fumage (candle flame passed over damp surface), bleaching, marbling, splattering, candle and wax crayon rubbings and drippings, spray stencilling, soap bubbling, printing— hands, fingers, waste materials, paste combing, dribbling, folding and blotting with inks and/or paint, folding and dropping in coloured inks, dyeing (with tea, coffee, fruit concentrate, dyes, inks), tinting (with water colours, food colouring).

Base

White or coloured cardboard, cartridge paper, sugar or pastel paper (colours sometimes tend to fade), brown paper, section of a cardboard packing case, strawboard [insulating board], hardboard with a coat of acrylic paint if a white surface is required, plywood, chipboard [paperboard], glass, stretched canvas.

Equipment

Newspaper for working surfaces placed

Above A natural form of décollage made from layers of weather-worn posters. *Right* Ideas for hand-decorated papers for collage using waste materials such as wood off-cuts, screw heads, doilies, printed on to plain and brown paper.

in a draught-free room, boxes, folders or plastic bags for storing papers, tracing or greaseproof [waxed] paper for transferring designs, scissors for paper cutting, including one smaller pair for details (surgical, hairdressers' or embroidery scissors are particularly recommended), formica or hardboard for a cutting surface, pencils, sponge or rags, crayons, pens compasses and set square, craft knife such as a multi-purpose snap-off blade cutter, metal rule, glue spatula or paste brush and glue container such as a yogurt or margarine pot, orange stick or toothpick for gluing small pieces, tweezers for moving small pieces.

Adhesive

There are several alternatives and your choice will depend on the amount you wish to spend and the desired quality of finish. Rubber solution is particularly useful for any temporary pasting down and may be removed when dry, by rubbing with the fingers.

Note: As a general rule, apply all adhesives sparingly.

Flour and water paste, wallpaper paste (not suitable for fine papers), rubber solution, PVA thinned down to milk consistency with a little water, solid white paste, glue pen for small areas.

All types of paint may be used in combination with collage but the acrylic-polymer colours are especially useful. These are mixed with water and are strongly adhesive, so that pieces of paper can be stuck directly on to the wet colour. If you wish to give your work some kind of protective coating, paper varnish or one of the acrylic-polymer mediums or varnishes will impart a matt or gloss finish. The latter appears as a milky liquid but quickly dries into a transparent film.

Design

The main advantages of paper collage and photomontage are the bold flat and three-dimensional effects, patterns or images created with minimum expense and skill. This is a useful factor in school, especially when materials are in short suply towards the end of the year.

In addition to adhesives, little equipment is required other than scissors and they may be unnecessary for often more spontaneous and lively results may be achieved by tearing.

Materials are possibly the smallest problem, for in these days of super-packaging and multi-wrapped goods we are surrounded by an abundance of paper, usually thrown away without a second thought. But if we look again into our waste paper baskets, a mass of

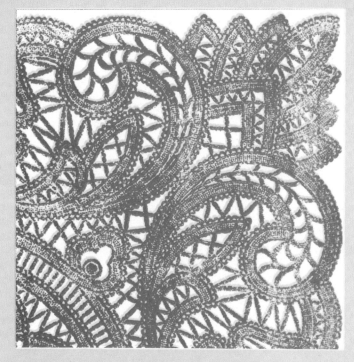

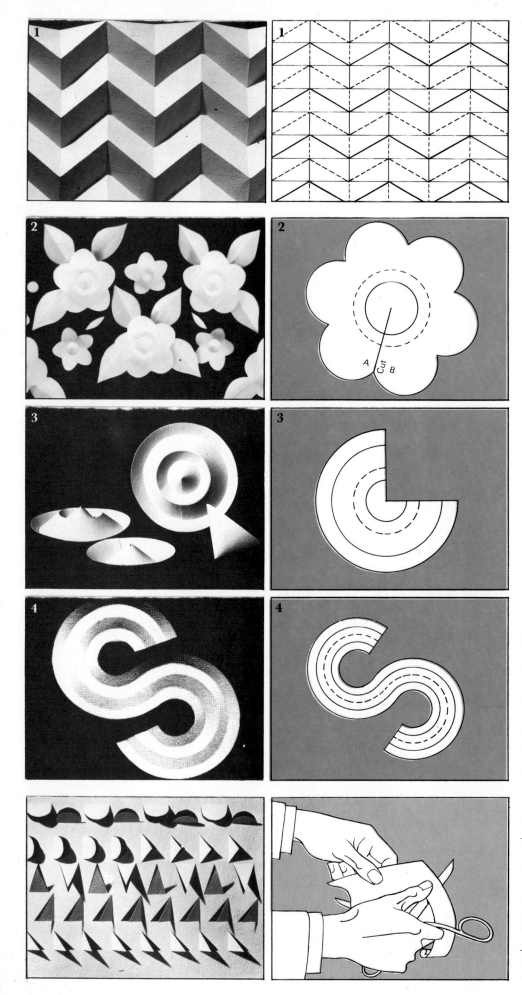

material is there for the hoarding. Once a collection has been started, much satisfaction and fun can be gained by making your own coloured, patterned and textured papers, further details of which will be given later in the chapter.

The medium is, in many ways, ideal for developing design awareness in colour, shape and pattern due to the brilliance and diversity of modern paper and the ease of moving it around on the background. It also has a nostalgic and illusory quality which can evoke moods and images (old photographs, postcards, letters and labels) thereby suggesting many possibilities for the expression of feeling.

Realism, however, is not a part of the character of paper and to attempt such is to aim for the impossible; the camera is the only solution. Better by far, to look around for objects and ideas which attract you as an individual and then to try and express them in your own personal way—even if you appear at the time to fall short of your ideals.

Suggestions for experiment

Warning: Before embarking on any paper collage, remember that thin cardboard and paper will tend to stretch and wrinkle during the pasting process, especially when the more fluid adhesives are used. This problem can be minimized by equalizing the tensions between wet and dry surfaces after they are coated with glue, through damping the backing paper with a soft sponge dipped in a diluted solution of the adhesive.

Collage for a blind person

The aim of this initial experiment is to explore the potential of paper as a tactile surface. In this way, only a few types of paper are required, plus some invention on the part of the creator. Children may enjoy thinking of this experiment as some kind of lunar land-

Left *Before embarking on a paper collage, time is well spent in discovering the potential of paper as a surface. This illustration shows ways in which paper may be folded, cut and curled to achieve effects in relief. Note how the technique is dependent on the source of light.*
Right *Marbled papers could be added to a collage. Special inks are obtainable for precise patterning and brilliant colours but attractive effects may be created with drawing inks and oil paints.*

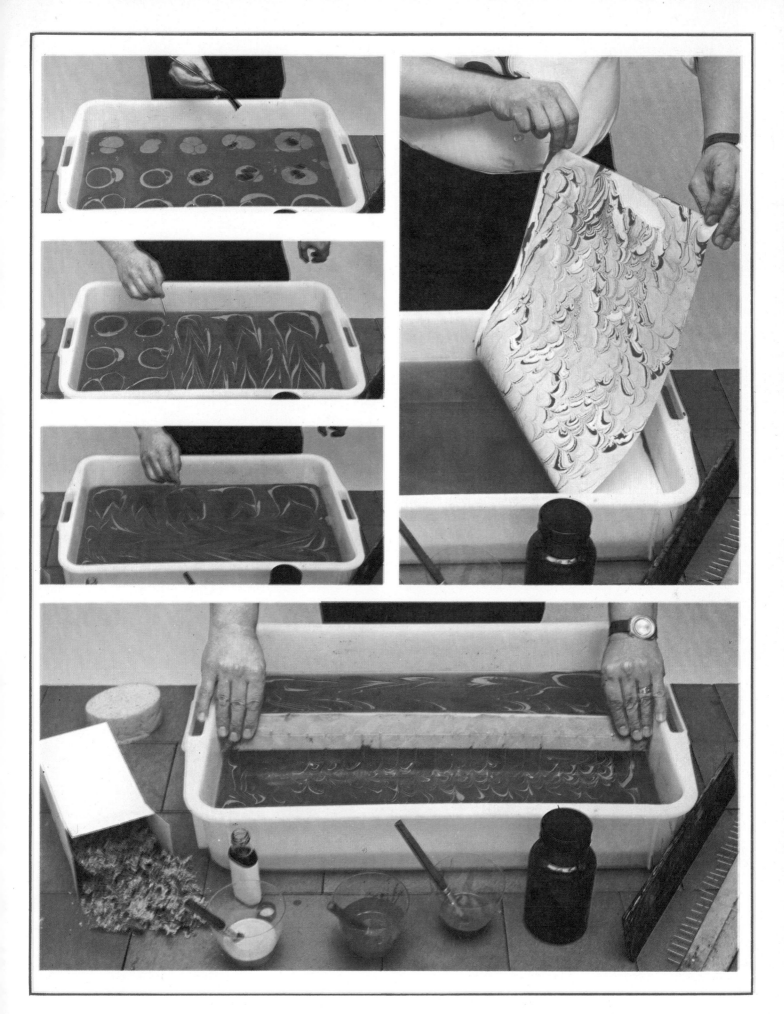

scape or other aerial view with mountains, lakes and caverns.

1　Select your background paper, card or hardboard and one basic type of paper for your relief forms—cartridge, shelf lining paper or aluminium foil would be particularly suitable. The latter offers plenty of scope for reflective surfaces, especially when combined with coloured foil, acetate etc.

2　Take one fairly large piece of your paper and crumble it into a fairly tight ball. Pull it back into a rough shape and, keeping some parts crinkled and 'hummocky', glue it down on to the base.

3　Having eliminated the problem of where to begin, build up your landscape from this point by using as many methods as you can invent for applying your paper.

Here are a few ideas:

coiling both thick and thin strips into cylinders.

folding into regular and irregular pleats.

curling by wrapping strips around a pencil, a knitting needle or, better still, with the opened blade of a penknife or pair of scissors.

looping and gluing strips into tunnels and hills, interweaving some pieces.

screwing and twisting into lumps and lines.

tearing and overlapping pieces for feathery effects.

partly cutting then bending or folding back.

moulding around sections of cardboard, cylinders, match boxes and egg boxes.

Tree silhouettes with or without foliage

Trees offer an endless source of design with their summer and winter foliage, varied leaf shapes and textural bark patterns. A scrap book on this theme could be invaluable and an inspiration for all forms of collage. It could contain anything relevant from pictures, sketches and photographs, to pressed leaves and bark rubbings. However, for this particular idea, a study of the total shape could be the starting point for a single tree or forest.

1　Select background paper or card in a colour which will contrast with your cutouts, for example, dark green trees on a pale green background, or black silhouettes on white or neutral.

2　Decide whether you want an effect of spring or summer foliage, winter silhouettes or a combination of both. Look around at your nearest tree or, if

Above *Strong colour contrasts have been created in this collage with an old campaign sticker, newspaper, photographs and crêpe paper.*
Below *A child has combined drawing and paper sculpture to make this Womble.*
Right *Collage for a blind person, using tissue paper, egg cartons and bottle tops to make a tactile surface.*

you are living in an arboreal wilderness, find a good photograph instead.

3 In either situation—study the form of your tree from the trunk and roots to the radiating branches and twigs, for these elements make up the total structure and give the tree its individual character. It will help considerably if you make a brief sketch with chalk or charcoal on scrap paper, emphasizing any line or shape which attracts you.

4 When you feel that you know your tree or trees, cut or tear out and assemble the main trunk and branch shapes, building up your outline in small areas with strip-like pieces of paper. Alternatively, the total silhouette could be first drawn, then cut out. Further silhouettes can now be built up by overlapping to form a dense network of branches and trunks. Wool, dyed string or strips of fabric could work equally well and contrast with the paper foliage.

5 Once you have created the main structure of the tree (with less detail for summer, as leaves will obliterate many of the branches), you can now go ahead with the foliage, arranging and gluing down both large and small pieces of paper by overlapping, crumpling etc.

Coloured tissue is particularly recommended for changing tones, achieved by overlapping. For Christmas and other festive occasions, sequins, acetate and foil can be added for further decoration. Leaf prints cut out and applied, or printed direct, are another possibility.

The versatility of paper silhouettes allows adaptation for many other themes such as bicycles and machinery, people and cars in the rush hour, glass houses and exotic plants, stained glass windows, projected images including the human figure, fantastic birds, fish and monsters.

Still life

The subject matter for the earliest *papiers collés*, created by Picasso and Braque, was inspired by simple still-life objects such as a café table, a glass, a slice of lemon and bottles. These commonplace articles are easily obtainable and have the added advantage of being static, allowing us time to observe their shape.

1 Choose a few items of varying sizes but related shapes and arrange on a flat surface where their forms can be seen clearly.

2 Take several sheets of fairly stiff paper in different tones, such as white, grey and black, or one colour in a range

from light to dark.

3 Tear directly or lightly sketch the outlines, then cut out your shapes. Symmetrical outlines such as bottles can easily be dealt with by folding the paper in half before cutting.

4 Now arrange your shapes by moving them around on your base, overlapping them if you wish, until you reach a balanced composition. Take away or add further ones if necessary, and do not forget that the background plays an equally important part in the whole design. Do not rush this stage and, from time to time, stand well away from your work and view it as a whole.

5 When you have reached a satisfactory arrangement, carefully glue down all your shapes.

6 If you wish to glaze your collage, when it is thoroughly dry, apply varnish with a large flat brush.

For further experiments, you could include your own patterned and textured papers, magazines, papers and newsprint, with tissue paper for overlapping shadowy effects. This simple approach to paper collage combined with photomontage, could be used for many different types of subject matter. Here are some ideas for further

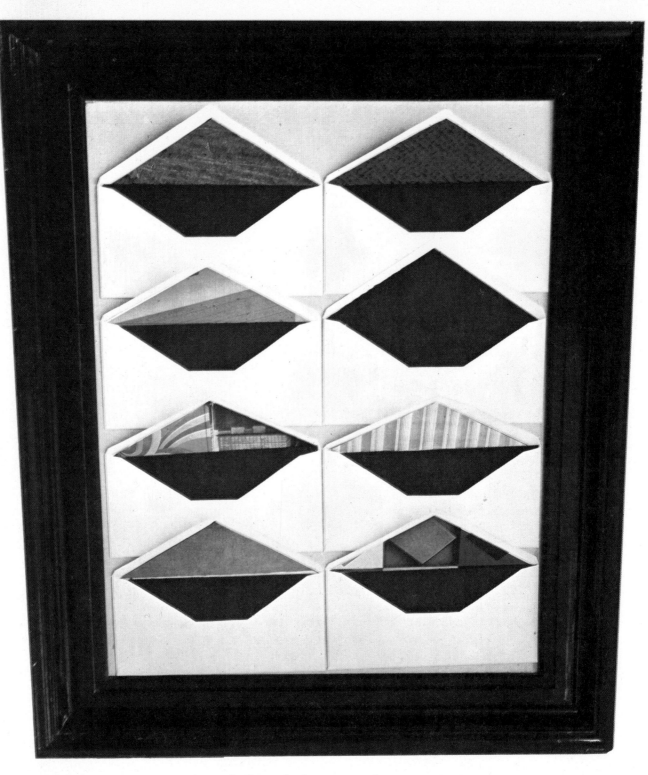

development.

Household equipment, view through a cardboard tube, view through a microscope or magnifying glass, interior design, advertising, letters, numbers, games, playing cards, heraldry, architecture, houses, churches, cathedrals, shop windows and markets, stained glass windows, human figure, portraits, costume, birds, beasts, reptiles, insects, flowers, fruit, vegetables, landscape, aerial views, machinery, trains, buses, cars, geometrical patterns, collision,

explosion of shapes, combustion of shapes.

Décollage still life

This technique, with its equivalent in fabric *découpé*, involves tearing or cutting away layers of paper which have been pasted one over the other. An everyday example of this type of collage can be seen on weathered poster hoardings, where posters have been peeled away and pasted over each other during a period of months and years.

1 Select four or more sheets of paper,

the same size as your base. For first experiments, thin paper such as tissue and tinted, dyed or printed kitchen paper, are most suitable as they tear easily.

2 Arrange your sheets in the order in which you wish the colours to appear; this could be in a gradual progression of tones or in strong contrasts.

3 Paste the bottom sheet on to a firm base such as cardboard or hardboard, and then the next layers one over the other.

Left Do not discard your old envelopes—re-decorate their linings with coloured or plain papers. In this illustration, note how the shapes of the lining papers take precedence over those of the the outer envelopes. The bright colours are responsible for this optical illusion. Try looking at familiar objects with half-closed eyes or from an unusual angle. It may give you ideas for similar designs. Right Slightly dampened tissue paper, folded and dyed with coloured inks, forms these attractive repeating patterns. Children enjoy doing this.

4 With a small sponge, moisten the area on the top sheet which you want to tear. Then peel the paper away, exposing the underlying colour.

5 Continue moistening and peeling through each layer, allowing the design to suggest itself. Yarn, sequins, small beads and coloured foil could later be added to enrich the surface. The whole can finally be glazed, when dry, with paper varnish on an acrylic medium.

Hand decorated papers

Textured and patterned papers can be created in numerous ways and will give your collage a more unusual and personal dimension. Why not try a few experiments, but remember to cover your working surface with plenty of newspaper before you begin?

Brûlage

Pass the slightly dampened paper (fabric or charred wood) over a candle flame to obtain burnt holes and edges.

As a safety precaution have a tray of water nearby for an extinguisher in emergency.

Fumage

Tone rather than charring is created by passing a tongue of smoke or smouldering wick over the dampened surface of the collage or photomontage.

Dyeing and Tinting

Using a small sponge, apply solutions of tea, coffee, fruit concentrate, coloured inks or cold water dyes. Similarly, water colours and food colouring will impart more delicate tints. By overlapping one colour upon another, allowing each to dry between applications, a further range of tone and colour may be achieved.

Bleaching

With a paint brush or a dropper, apply a diluted solution of household bleach to dyed or bought paper.

Splattering

Dip an old toothbrush into paint or ink and pass your thumb or the end of a paintbrush over the bristles to splatter the colour. Flicking a paint brush will achieve similar results but can be a hazardous business.

Potatoes, leaves and waste materials

Place an extra wad of newspaper on your working surface, then mix a fairly thick solution of powder, poster or gouache paint in a small saucer or lid. Cut a pad of foam approximately 0.6cm (¼in) thick to fit your container and immerse it in the paint. Use this as your printing pad for a potato cut in half, or any waste material such as cardboard cylinders, cotton reels [spools], wood blocks, lids and crumpled foil.

Regular and irregular patterns can then be stamped on to any type of paper. Hand, finger and leaf prints can be created by the same method.

Monoprints

Select a non-absorbent surface such as formica or glass and paint or sponge the surface with a thick layer of paint. Using fingers, brushes, pieces of card etc. 'draw out' your pattern or texture. Then place your paper face downwards, on to this base. Press down thoroughly with a soft rag and lift the paper carefully when the print has taken.

Marbling

Three-quarters fill a large, plastic bowl with water. With a brush or dropper, 'float' one or several coloured inks or oil based paints. Place a thin sheet of paper on the surface, leave for a few seconds until the edges curl up, then quickly remove.

Soap bubbling

Blend a solution of washing-up liquid [dish washing liquid], soap flakes and hot water in a shallow container. Add paint or coloured inks and blow into the mixture with a straw, to create a deep layer of foam. Scoop up your bubbles with a piece of fairly stiff paper and allow them to settle and pop into patterns. Other colours may be added to the mixture and further layers of pattern created on the original piece of paper.

Dribbling and blowing

Using either ink or a fairly thick solution of paint (powder, acrylic, PVA, or poster colour), pour a small amount on to non-absorbent paper.

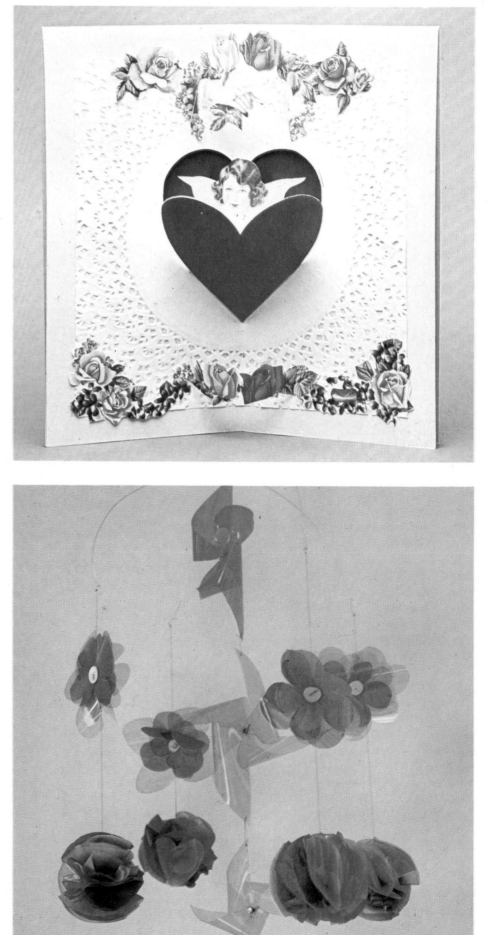

Left above *Greetings cards offer plenty of scope for collage.*
Left below *Curled paper mobiles can be easily made and look pretty.*
Right above *A collage to show the versatility of paper as a raised surface.*
Right below *An Italian mosaic carefully copied with* tesserae *of paper.*

Carefully tip the paper in all directions, not allowing the liquid to drip off the the edge. Alternatively, the liquid paint may be blown into rivulets with a straw.

Candle and wax crayon rubbing and drippings

Using either a candle or wax crayon, take a rubbing on to shelf lining paper or similar paper, from a textured surface such as coarse cloth or wood. Then, if you wish, paint the waxed surface with ink or a wash of paint. Further textures can be created by dripping candles or heated wax crayons on to paper, and adding paint and ink, or ironing grated particles of wax crayons between non-absorbent layers of paper.

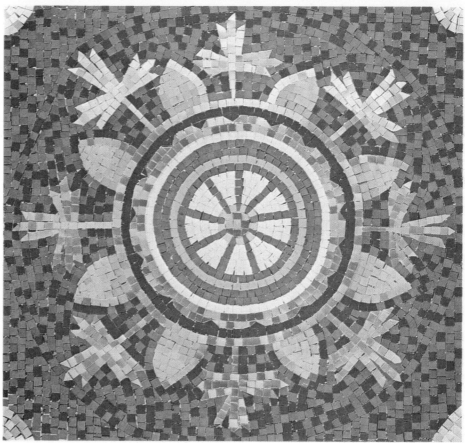

Metal

Compared with the history of man, the use of metal is relatively new, for even in the more highly developed societies, iron has been employed for less than 3000 years.

Due to improvements in smelting and moulding in the eighteenth century, the manufacture of artifacts was transferred from man to machine. This revolutionary change has profoundly affected the history of mankind, so that today we live in a world totally dependent upon technology for survival.

It is generally agreed that the artist is the litmus paper of society, expressing life as he sees it in his own time. Paolozzi and Stankliewicz are two such people, who, rather than isolating themselves from this rapid technological change, have accepted and utilized its wastage in the creation of their metal assemblages.

Our garages, garden sheds and cupboards are probably full of bottles, boxes, jars and cans crammed with every kind of hoarded ironmongery. Further afield, council and private scrap yards, jumble and rummage sales and road-side junk are worth investigation. So why not look around and try this medium for yourself?

Materials

Small—dressmakers' and safety pins, drawing pins [thumb tacks], hooks and eyes, hair pins and grips [bobby pins], metal combs, paper clips and fasteners, curtain rings, coins, nuts and bolts, washers, screws, nails, hinges, chains, ring pulls from cans, rings from film spools, cans and can lids, bottle tops, keys, badges, knitting needles, florists' wire.

Large—machine parts, cars, radios, television sets, wire mesh—chicken wire, gauze, metal foil, sheet metal and offcuts, metal tubing, knives, forks and spoons, graters and strainers, galvanized iron wire, springs.

Base

This must be firm to prevent warping. Plywood, harboard (backed with a frame for large, heavy collages), metal, fibreboard, cardboard for light weight metals such as curtain rings.

A rich reflective design has been created with a variety of nails and studs of different colours hammered into a soft board base at several levels.

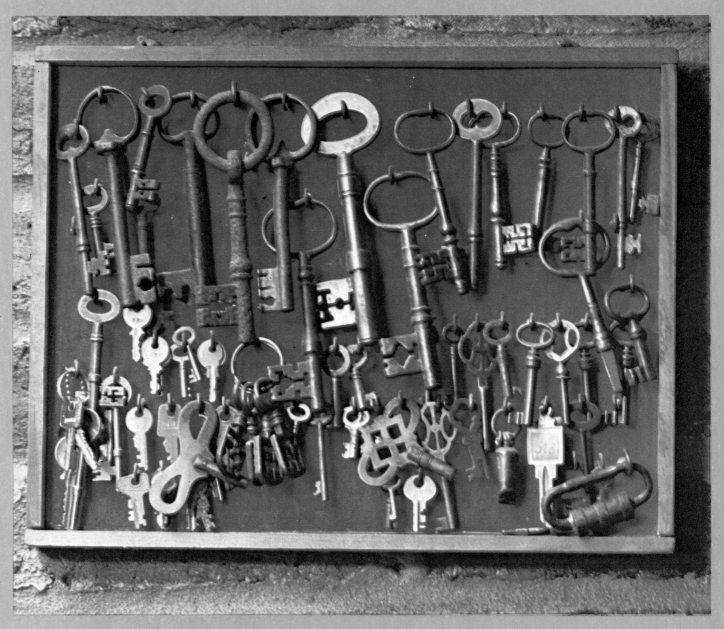

Equipment

Wooden board or work bench, a vice [vise], if possible, for holding objects when you are cutting or sawing, tweezers for moving small objects, pliers, wire clippers, wire cutters, tinsmiths' shears, can opener, metal skewer for punching holes, metal file, hacksaw for cutting rods and thicker metals, small clamps.

Adhesive

PVA for light weight items, contact adhesive, epoxy resin for heavy objects —cogs, chains etc.

Design

As in all collage, the previous life of the found objects will have a direct bearing on the nature of the work. The shapes, colours and textures, may inspire your design. Alternatively, the objects themselves may create a new image. Do not be deterred by rusty,

Collage or a key board for the forgetful? Collage and reality mingle in this attractive metal display.

crumbling surfaces, instead, look closely at the rich colours and textures and utilize these weather-worn characteristics in your collage.

Suggestions for experiment

Metal assemblage

1 Remove any grease from metal parts, otherwise they will not adhere.

2 Arrange the objects on the base. Glue down one at a time and leave them to dry. Alternatively, you could compose a whole panel of nails and pins, hammered or pushed into wood or fibreboard. If they are set closely to one another and sunk at different levels, the effect can look very attractive.

3 Finish with a coat of lacquer or spray paint.

Metal parts set in plaster

Note approximate proportion of plaster to water 11:7 measures.

1 Lightly glue objects, face downwards, on a base. For a small experiment, this could be the lid of a shoe box.

2 Sprinkle plaster through the fingers into a plastic container filled with water, until the plaster is approximately 0.6–1cm ($\frac{1}{4}$–$\frac{1}{2}$in) below the surface.

3 After the mixture has settled and the air bubbles have dispersed (about one minute), stir the mixture thoroughly with your hand, to a creamy consistency, breaking up any lumps with your fingers. Avoid withdrawing your hand until the mixing is complete so that the minimum amount of air enters the plaster, for it sets very rapidly.

4 Quickly pour the plaster into the mould. Immediately press in a piece of builders' scrim the size of the lid. This will reinforce the base.

5 As soon as the plaster has set, the lid may be gently turned over and the cardboard peeled away, soaking it with a sponge where necessary.

6 Clean away any excess plaster with a soft brush. Add colour if desired—acrylic paint, water colours and shoe polish are all suitable.

7 Varnish with an acrylic medium.

Imprints of metal parts in plaster

1 Roll out a 2.5 (1in) thick base of plasticine or clay on a rigid base such as formica or hardboard.

2 Press your objects into this soft base and remove each one carefully to leave a clean imprint.

3 Surround your imprints with a 3.5cm (1$\frac{1}{2}$in) wall of plasticine or clay, taking care to seal the joins.

4 Continue as in stages 2 to 7 of the previous experiment, peeling away the plasticine when the plaster is completely set. Further objects could then be built up on small quantities of plaster, giving positive and negative effects.

Mobiles

Glittering, tinkling mobiles may be made out of the cans which we throw away without a thought, unaware that we are discarding metal which can look very attractive.

The tops and bottoms of cans may easily be removed with a good can opener, then washed, dried and stored away over a period of weeks, depending on your diet. Here are a few suggestions

Blacksmith's nails stuck down on a board form this symmetrical design. This idea is a symbolic interpretation of a traditional Inca breastplate.

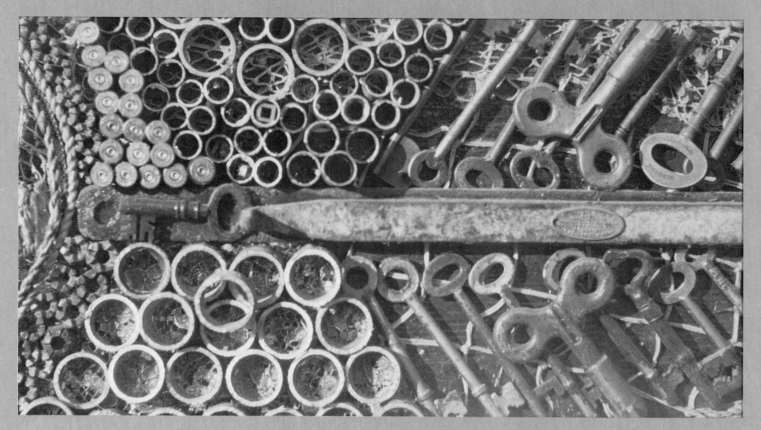

on constructing your mobiles with the inclusion of other metal objects.

1 Stipple the surface of the metal by placing it on a soft pad of newspaper and pounding it on both sides with the rounded edge of a hammer.

2 Perforate the surface with patterns using a nail, chisel or sharp pointed instrument.

3 Fringe, curl and twist the metal with pliers.

4 Cut it into star shapes, hexagons, triangles, squares and so on. Mark out the lines first with a felt tip pen, then cut with tinsmiths' shears.

5 Add surface decoration by sticking on washers, hair pins, ring pulls, coloured foil and sequins.

6 Combine shapes with mixed lengths of metal tubing and moulded wire.

For a good finish, all sharp and turned edges should be filed down and, if desired, the mobiles coated with a clear lacquer. Fine wire or nylon fishing line is suitable for suspending the objects from horizontal lengths of a thicker wire or metal rods.

Warning: it is advisable to wear an old pair of gardening gloves to protect your hands and fingers when cutting and bending the lids.

Above Detail of a fish monster created from all sorts of metal junk.
Below Do not throw away empty cans—with patience and careful cutting, they could *be used for a metal collage.*
Right Figures may provide a source of inspiration for design. Watch parts and feathers are used as basic materials.

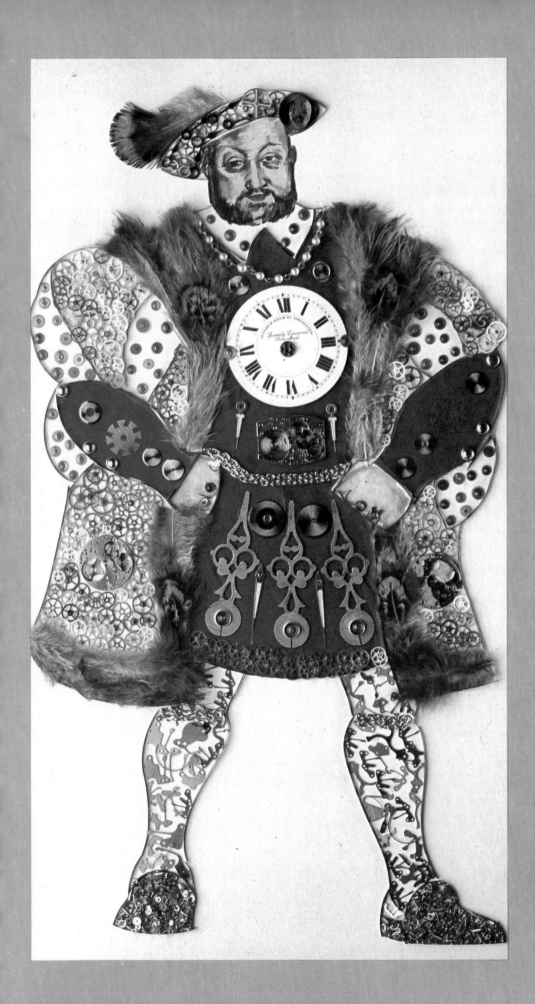

Natural objects

For people who have never learned to write, art is an expressive substitute for literature, closely interwoven with tradition and religion. Both primitive and prehistoric man show in their art forms a diagram of life as they see it, often in terms of symbols, rather in the same way as we would interpret a road map. The materials they use are unsophisticated, usually gathered locally and well suited to their bold and beautiful designs.

Rice powder painted in images on dark mud walls, and silver foil pasted upon impressed clay handprints are types of collage employed by some secluded hill tribes in India. On the other side of the world, the Navaho Indians of Arizona, Utah and New Mexico are renowned for their sand paintings. The origin of these is uncertain but they had a magical purpose to obtain the presence and assistance of supernatural powers. They were made by the medicine man on the floor of a specially built log cabin. Chanting a magic formula, he trickled finely ground sandstone, charcoal, powdered roots and bark through his fingers on to the smooth base, forming intricate patterns, plants and figures. The only tools which he used were a wooden rod for smoothing the sand and a length of string for marking the guide lines. At the end of the ceremony, the power having been transferred to a human body, the remaining design was rubbed out and the sand deposited outside the building.

Although we may experiment with similar materials, there is no reason why others may not also be incorporated

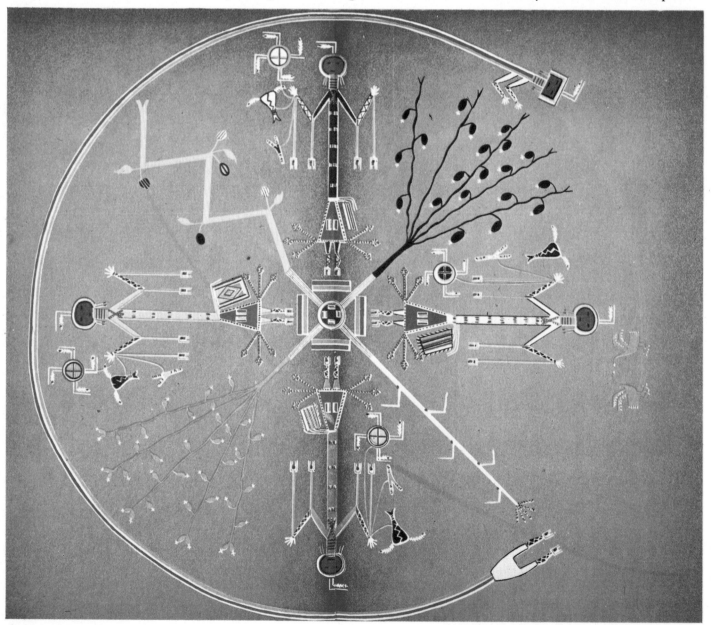

into our collages, according to the season and the locality. Young children will particularly enjoy working with the medium and will respond to its earthy qualities.

Materials

Sand, earth, gravel, wood ash, sawdust, dried tea leaves and coffee grouts, salt, grass cuttings, orange and grape fruit peel, crushed chalk, charcoal and coal, egg shells—whole or crushed, feathers, bones, shells, stones and pebbles, wood shavings, chippings and offcuts, cork, bark, twigs, straw, seed heads, driftwood, nutshells, fleece, animal and human hair.

Base

Plywood, hardboard, cardboard.

Equipment

Transparent containers for materials, spoon for transferring sand, sawdust etc., tweezers for smaller items, old scissors, small handsaw for cutting wood, glass paper, craft knife, chalk, crayons or charcoal for marking out the designs.

Adhesive

PVA, white glue

Design

The primitive 'earthy' character of these natural materials should be sensed and fully utilized in the design. Many of the materials can be poured on to the glued base suggesting flowing lines or textures, and others have similarities with *tesserae* and may be used in a mosaic-like manner. A combination of flat and raised areas could produce a range of varied surfaces and provide a worthwile exploration of texture and colour.

Dyeing and painting any of the objects would seem a waste of time as

Far left *This example of a mystical Navaho sand painting calls upon the gods of agriculture for a good harvest and for healing.*
Below *A particularly fine example of strata patterning in the Grand Canyon, North West Arizona, could provide an inspiration for collage with natural objects.*

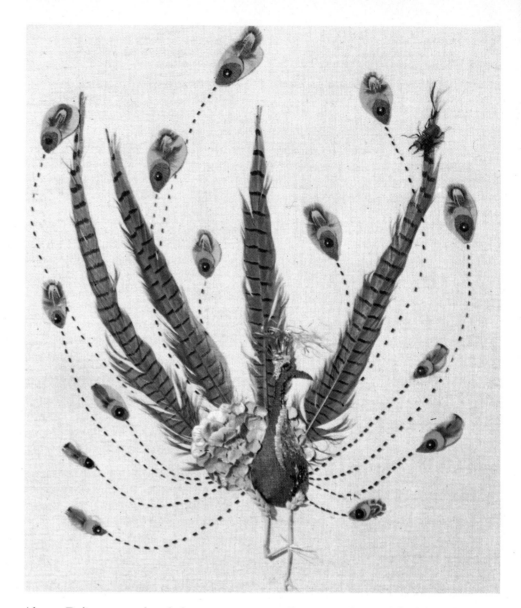

Above *Delicate peacock and pheasant feathers with some dried plant material are assembled to form this exotic bird with natural colouring.*

their natural colours are subtle and beautiful. However, an application of varnish or PVA medium can enhance shells, bark and pieces of wood.

The attractive surfaces and colours of these natural objects have an immediate appeal to our visual and tactile senses. Working with different textures or varying shiny surfaces direct on a base may be preferable to working in a planned manner.

Suggestions for experiment

Sand and gravel painting

Designs for this ancient technique should be kept fairly simple and it is essential to work on a firm base of heavy cardboard, hardboard or plywood.

1 With chalk or charcoal, draw out the main areas of your design on to the base.

2 Prepare the sand by sifting it through a very fine strainer to remove any debris. Sort the colours into transparent containers. Soft rocks can be placed in a strong paper or cloth bag and pounded with a hammer on a concrete surface.

3 For crisp borders you could, at this stage, outline your main shapes with string, cotton yarn or twine. Glass paper cut out and stuck down on to the base in certain parts could give further contrasts in texture.

4 Spread a very thin layer of white glue inside one section of the design. Sprinkle sand or gravel on to the area and tramp it down firmly with the back of a spoon. An orange stick or tooth-pick will enable you to spread the sand into awkward corners and crevices.

5 To 'fix' the sand and gravel, a solution of one part glue to two parts water may be trickled over the materials as each section is finished, completely

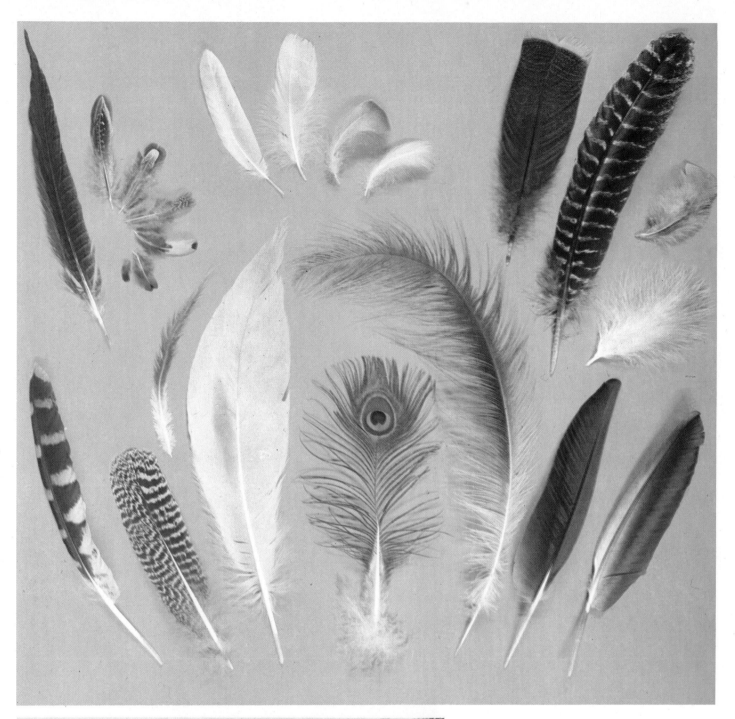

Above *A selection of common and rare feathers, showing a beautiful range of patterns and subtle colours.*
Below *Patterned and plain feathers combine to form a larger feather shape.*

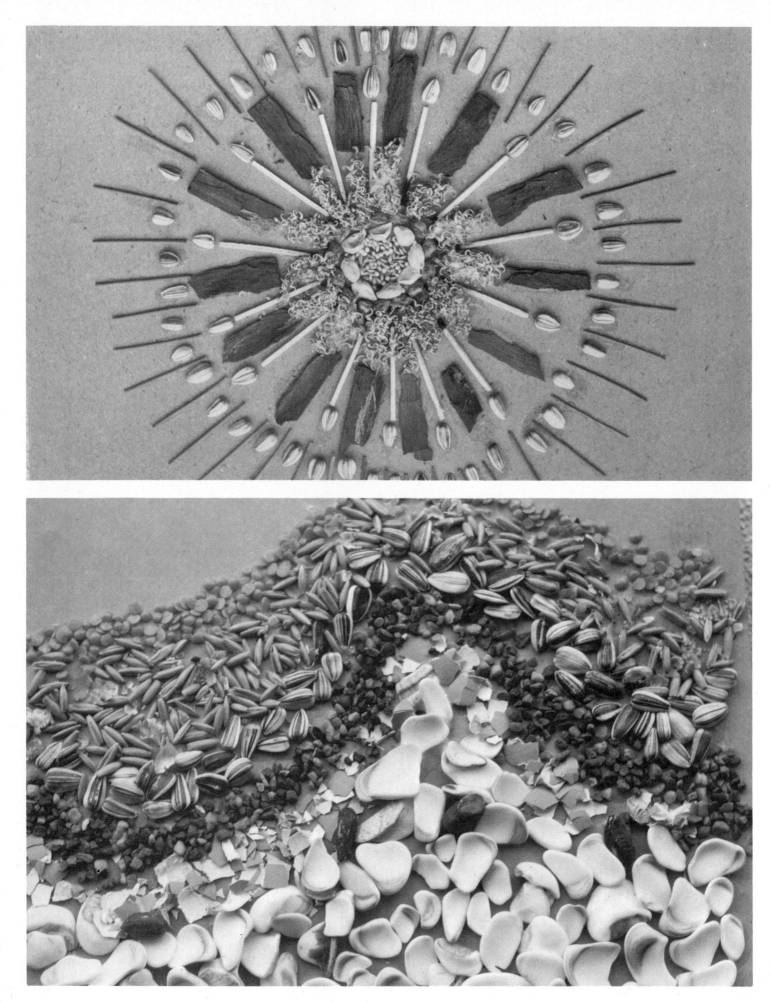

saturating it. A soft brush will help to distribute the liquid.

Strata

Looking at strata is a good source of design. Strata may be seen in natural forms such as rock compressed through the millenia by powerful forces. Think of a 'sandwich' rippling with pattern, the filling varying in thickness and tone, folding, contorting and breaking up in parts, according to the erosive action of the elements.

If possible, go out to a local sandpit, escarpment or cliff face and make a quick drawing of the layered formations, noting the changes in proportion and tone. Alternatively, study photographs and pictures of rock strata and cross-sections through stone and marble. Some pebbles picked up on the seashore often have these layered patterns in miniature.

1 Select your base and draw out the main lines of your layers with chalk or crayon. Vary the proportions.

2 Glue the divisions or layers, step by step, making the collage in this way. Occasionally stand away from your work and view it as a whole. You may find it easier to apply the more powdery substances with a teaspoon to avoid any spillage. Press down all material firmly.

Aim for constrasts in texture and tone, for this will enliven the appearance of the surface. If you wish, leave some areas plain as a further contrast. Powder paint mixed with sand produces a further range of colours.

3 If required, varnish certain areas with a PVA medium. String, twine and other natural fibres could also be incorporated into this design.

Egg shell mosaic

A fairly small base, about 20cm (8in) square, is required, otherwise the task of sticking down the pieces will seem endless.

1 Crush egg shells in a paper bag and transfer them to a plate. If you wish to dye the shells with food colouring, do so at this stage. Dry them thoroughly on newspaper, then sort them into separate containers. Alternatively, leave the crushed shells in their natural state and work with tones of brown and white. This looks very effective when varnished.

2 Work out a simple design on paper and transfer it to the base with chalk or charcoal. Keep the areas to be collaged fairly large for a bold effect.

3 Glue each part before applying the egg shells. Varnish with a PVA medium and wash your brush out immediately afterwards.

Many of the Roman and Byzatine mosaics could be a source of inspiration for further designs.

Asymmetrical pattern with geometric solids

Dowelling and offcuts can be bought relatively cheaply and are suitable for this kind of design. However, access to a workshop is an advantage for this experiment.

1 Choose a simple unit suitable for repetition. This could be sawn sections

Left *Radial and strata designs composed of tree bark, rushes, seeds and shells.*
Above *Off-cuts of wood display their attractive graining in this assemblage.*

of dowelling or laths or one of various geometric solids, such as cubes or cones. It will only be possible to guess at the number required at this stage. A contrast in scale, tone and markings on the various types of wood, will give an added dimension to the final work.

2 Select a base of hardboard or plywood and cut it to a size and shape which relate to the smaller applied shapes, such as a circular base with cylindrical solids.

3 Arrange units on the base. Cylinders might form one or several interlocking spirals, cubes could be arranged on a grid system, some built upon others, giving an almost three-dimensional effect. Spend some time at this stage until you are certain of your composition. If you are unsure, leave the panel for a few days in a place where you will see it frequently. Living with a problem often helps the solution.

4 Give your solid units a craftsman's finish by smoothing them with glass paper wrapped around a block of wood so that no rough edges remain.

5 Glue the units down and leave them to dry.

6 Rub in beeswax and polish with a soft cloth for a matt finish or alternatively, apply glossy polyurethane varnish.

Photo-montage

This technique is another form of paper collage and originally could be described as the pasting of assembled photographs, whole or in part, into a montage. It first made its appearance about the middle of the nineteenth century when it was used in photographic studies at popular seaside and spa resorts the world over to form romantic, panoramic views against which the tourists could pose for their portraits. It was later, in the period after the First World War, that old letters, newspapers and drawings were also incorporated.

In the 1890s it was used for the first time in posters but its real potential was brought to light by the Dada movement which came into being as a result of the shock aftermath of the First World War. This group of artists sought to scandalize and outrage the public with their deliberate anti-art attitudes. The German artist, John Heartfield, used photomontage for political ends. Since then, many artists from widely differing backgrounds have explored this form of collage to express what often emerges as the world of the unconscious, the other reality filled with dreams, nightmares and apparitions. In a different way, the recent pop art movement has been using photomontage in combination with printing and painting as a comment and statement on contemporary society.

Essentially, photomontage is a record of one time, for the majority of materials used, such as magazines, catalogues, greetings cards and postcards, are a reflection of the artist's life style as well as his own personal interests.

Materials
Black and white and coloured photographs, magazines, postcards, greetings cards, posters, notices, catalogues (gardening, mail order etc.), labels from cans and bottles, packets, theatre programmes, travel brochures, old letters, newspapers, typescripts, stamps.

Base
White or coloured paper, cardboard, hardboard.

Equipment
Box or folder for storing papers, scissors with sharp point and blades approximately 15cm (6in) long, for paper cutting, craft knife for cutting awkward areas, metal rule, cutting board, paper varnish for coating the final result if a gloss finish is wanted.

Adhesive
White PVA thinned down with a little water, wallpaper paste, white paste, flour and water paste.

Design
Photomontage, like many other forms of collage, primarily involves working with shapes. The material lends itself most readily to formal composition; colours and textures will emerge as a result. From time to time, look at your work from a distance and ask yourself these questions. Do the cut-out and

Below *Two separate photographs of a girl's head and a dew-laden flower are cleverly combined to create this dream-like photomontage.*
Right *Magazine and newspaper cuttings are readily available for this simplest and most common form of photomontage.*

torn shapes fit comfortably into the background area? Have some parts been left free for a visual 'breathing space'? Is there enough contrast of scale and size of shapes? Have too many colours been used? Would black and white, or tones of one or two colours, be more effective?

Suggestions for experiment

Patchwork patterns

1 Choose a favourite colour and select about a dozen papers from various sources in that particular colour scheme. Try to find a range of tones in your materials, that is, ones which vary from light to dark in colour such as pale pink to deep red.

2 Make one thin cardboard template, approximately 5–8cm (2–3in) long, of one of the following geometric shapes —square, rectangle, diamond, triangle, hexagon. Use this each time to draw round, and cut out as many units as required.

3 When you have cut out about a dozen, push them around on your base until you can decide on a satisfactory arrangement. This could begin at a central point and grow outwards, or work in horizontal or vertical stripes. The shapes could cover the whole of the base as in a jigsaw puzzle, or some spaces could be left to form a second, background pattern.

4 Glue down. Cut out and add further patches where necessary. Do not over-glue.

Montage with a theme

What is your special interest—the pop world, films, theatre, fashion past and present, birds, animals, flowers, travel, trains, ships, cars, cookery? Whatever

Previous page *Dream, nightmare or apparition? To achieve this unusual photomontage, great care has been taken in dove-tailing the separate photographs to avoid any visible joins and give an added sense of realism.*

Above *This photomontage by the artist Richard Hamilton is called* Towards a definite statement for the coming trends in menswear *and needs no further comment!*

Below *Photomontage can be used as a medium to attract public attention. In this instance, Richard Hamilton has distorted the face of the late British politician, Hugh Gaitskill, as a protest against his nuclear policy.*

the subject, begin collecting your materials now and put them away in a folder.

1 When you have gathered enough to cover the background desired, carefully cut out your pictures and assemble, perhaps working from the top downwards, overlapping some of the shapes. Consider the mass shape which you have created and leave some of the background clear.

2 Glue down when the overall design looks satisfactory.

Surrealist montage

Whether or not we realize it, we all dream every night. People, events, places, objects, drift through our subconscious in a strange, topsy-turvy, sometimes beautiful, but often alarming manner.

This is just the subject matter for your surrealist montage.

1 Assemble your cut-out and torn material in a variety of size and diversity of subject matter according to your original idea of a pleasant dream, terror-stricken nightmare, or combination of both. Remember, variety of scale can lend a surprise element, for example, the large apple filling an entire room by the Belgian artist Magritte.

2 Glue down your shapes when you have achieved the effect you want. Do not forget that the background space has an equally important part to play in the final design. You might want to utilize chance and accident in the assembling of your shapes so that you mix up your material, take pieces at random and throw them down on your background. Repeat until a satisfactory result appears, expressing your feelings.

Travel mementos

Update the old scrapbook idea by creating one large photomontage of your holiday. All kinds of mementos could be included, for example, postcards, travel brochures, bus, air or train tickets. Some pictures could be left complete while others could have certain parts cut from them and arranged to make further, larger shapes. The tickets and other ephemera could be added in certain areas to enrich the whole.

Several photographs of a girl, a shoe and a fish tail have been combined to form this surrealist photomontage. Using pictures in different proportions achieves an eerie and unsettling effect.

Bits & pieces

Bits and pieces virtually encompasses junk of all descriptions and will inevitably overlap with the 'found objects' suggested in other chapters. The only real problem is storage space, but clear plastic or glass containers for the small items, and plastic bags for the larger, will simplify classification and identification if you stow them away in boxes, cupboards and drawers.

Should you be short of any oddments, you will find rummage sales and jumble sales indispensable sources of thrown-out treasures.

Materials

Bits—buttons, beads, sequins, old jewellery, buckles, bangles, curtain rings, studs, hair grips [bobby pins], hooks and eyes, cotton reels [spools], shoelaces, safety pins, rubber bands, paper clips and fasteners, clothes pegs [pins], glass bottles, old china plates etc., corks and bottle tops, mirrors, match boxes and spent matches, cigarette packs, pipe cleaners and spills, cardboard cylinders, ice lolly sticks, old records, jigsaw puzzles, counters, parts of broken toys.

Pieces—leather, fur, plastic sheeting, plastic bags, foam rubber, fruit and vegetable bags, polystyrene moulds and offcuts.

Base

The choice depends on the weights of the objects to be used. Hardboard, cardboard, strawboard [insulating board], plain or paper-backed hessian [burlap], polystyrene tile, plywood.

Equipment

Newspaper for working surface, tweezers and orange sticks or toothpicks for applying glue to small objects, hacksaw or hot wire for cutting polystyrene, pliers and side cutters for tougher items, an old pair of scissors, craft knife, strong paper bag and a hammer for breaking glass bottles, china and mirrors.

Adhesive

PVA for all card, plastic and polystyrene, contact adhesive for heavier items such as glass etc., epoxy resin and hardener.

Design

The predominating number of 'bits' over the 'pieces', suggests that this medium lends itself to a mosaic form of collage. This is one of the earliest and most durable techniques of floor and mural decoration and was constantly

Right Childhood ephemera have been stuck to a wooden base to create this collage, evocative of time-gone-by.
Far right Reflective surfaces may be created on a small scale with a variety of beads and sequins. Tweezers are invaluable for arranging and sticking.

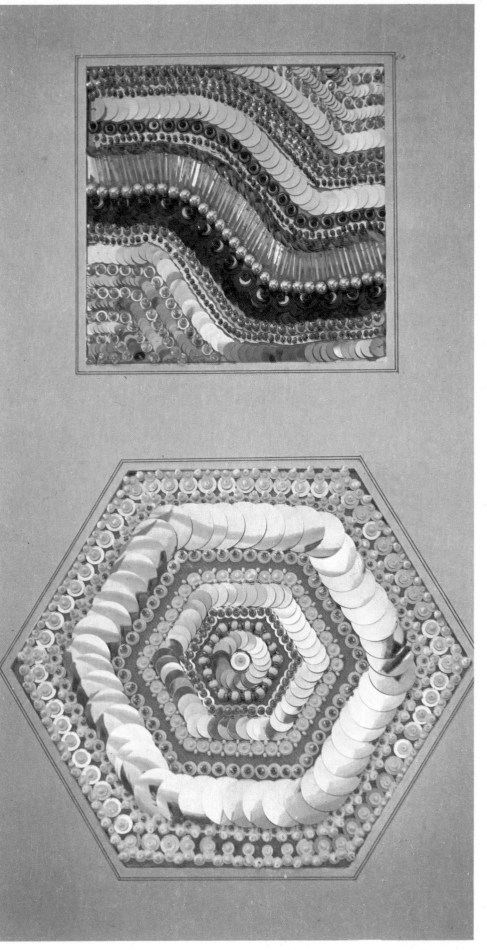

employed from earliest times up until about the thirteenth century. The early Christian and Byzantine churches in Italy, Sicily and Greece are particularly famed for this method of decoration, laboriously built up with small cubes or *tesserae,* clipped from slabs of coloured marble, stone and glass, and then embedded in cement.

In this century, Antonio Gaudi, the Spanish architect and designer, and Simon Rodia, creator of the Watts Towers in Los Angeles, have also invented their own highly individual forms of mosaic to decorate the surfaces of their buildings with glowing assemblages of rich pattern.

In Britain, a number of schools and public buildings are decorated with mosaics—some done by the children themselves in a variety of materials and ways of pressing in the pieces. Some particularly fine examples of mosaics are to be found in the National Gallery and Westminster Cathedral.

The subject matter from both historic and contemporary sources offers plenty of ideas for interpretation, setting the mosaic in either plaster or cement, or sticking it on to a firm base with a strong adhesive. Here are a few suggestions—figures full length or portraits, flora and fauna, geometric and abstract patterns and architectural features and forms.

Suggestions for experiment
Kaleidoscopic pattern
This idea, inspired by the multitude of symmetrical designs created by a bought or home-made kaleidoscope, could be adapted to both small (greetings cards) and large (wall hangings) motifs, according to the scale of the chosen objects.

1 Select base and colour scheme. Silver, gold, tones of one colour, several contrasting colours or a mixture sprayed with an overall finishing coat of coloured metallic lacquer, are just some of the possibilities.

2 Place one object at the centre of your base, and work outwards from this point, layer by layer, taking care that the shapes and colours are symmetrical. Try contrasting different surfaces and shapes with lines, such as buttons with matchsticks.

If you find so many shapes confusing, why not work with only circular shapes such as curtain rings, buttons, sequins or cardboard cylinders cut to varying depths? Leather, plastic sheeting and foam rubber offer further opportunities for added symmetry and enrichment, as they can easily be folded into halves or quarters, then cut.

Mosaic banner
Assemble all your scrap materials—

Above *Detail of a collage mosaic mural. Tiles, stones, shells, clock parts are embedded in a cement base.*
Right *Bits and pieces of all sorts can be assembled to make unusual jewellery.*

glass bottles, mirrors, bottle tops, plastic lids, etc.—in fact, anything you can find among your bits and pieces which is not too heavy. A strong adhesive, capable of sticking the above items is essential for this experiment.

1 Cut a length of hessian [burlap] or sacking to a manageable size. Unless you want a frayed edge, which can look very attractive, turn your edges under and sew down.

2 Work out several symmetrical designs, using a folded rectangle or cut paper. Alternatively, select an idea from a book of patterns.

3 Choose your most suitable design and transfer it with chalk on to the hessian [burlap], enlarging it 'by eye' as you work.

4 Paint in the solid pattern with a thick mix of powder, acrylic or poster paint, or a strong solution of cold water dye. This will form a bold background on which you will be able to build your design and, at the same time, eliminate any errors in marking out.

5 Now carefully break your glass bottles, mirror, etc. into small pieces,

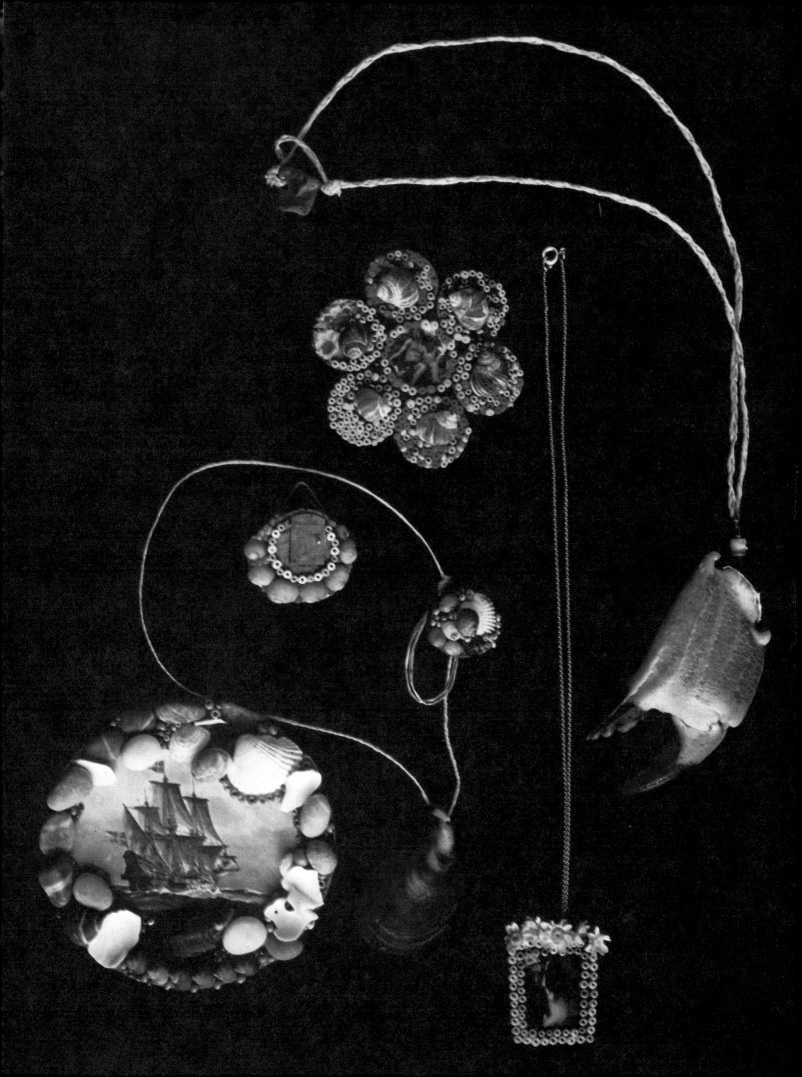

taking the following precautions:
> cover your working surface with plenty of newspaper
>
> place glass, etc. into a strong paper bag
>
> wear a pair of plastic or leather gloves (goggles, if you feel safer in them) and hit the bag with a hammer several times.

6 Grade glass and other oddments into colours and sizes and arrange your mosaic into the painted background. Do not worry if the design is not too precise.

7 When you are satisfied with the composition, stick down each piece separately. With glass, china and metal, coat both the area to be stuck and the object with a layer of glue and leave to dry until 'tacky', then press down on to the design. Felt tip pens can be used to give extra colour and richness to mirrors and glass (apply to the back).

8 Complete your banner by sewing tabs of tape of the same background fabric through which you can slot a pole or dowelling.

Personnage

During the 1950s, Eduardo Paolozzi, the British-born artist, became interested in the possible application of collage for sculptural techniques. He used urban bric-a-brac to create new forms which he then carved, modelled and cast into strange presences. Some of the objects listed in his creations include a toy camera, broken comb, clock parts, a dismembered lock and parts of a radio. On a smaller scale the idea of 'a personnage' or 'dream machine' could be interpreted on a flat two-dimensional base.

1 Collect and sort your junk into transparent bottles, bags etc.

2 Emulsion or prime your hardboard or plywood base.

3 Assemble your bits and pieces directly on the base. Aim for mass, so that the surface form is tightly packed with collage materials, some built up on on top of the other, but within a simple shape.

4 Stick down with a strong adhesive when you are satisfied with the composition.

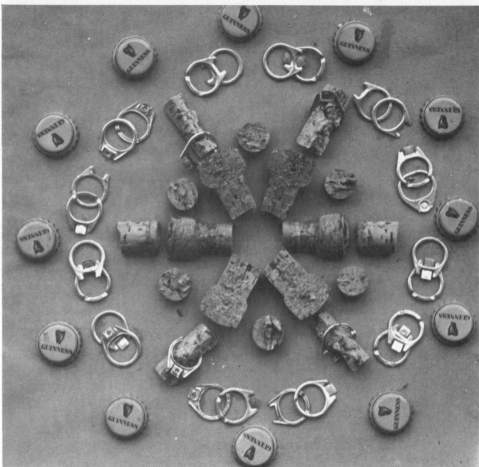

Left *Experiment with bits and pieces, cutting them and combining them. Match boxes, match sticks, corrugated cardboard and cut up plastic or paper cups, are particularly versatile, as well as very handy, for this type of collage.*
Above *Toothpaste tubes, detergent bottles and buttons are some of the objects used in this snowflake collage.*
Below *Corks, bottle tops and ring pulls form this radial pattern. Note how the contrasting surfaces give vitality.*

Fabrics

The original meaning of collage is that of pasting and gluing to a background but contemporary collage also includes *appliqué*, the application of pieces of fabric to a background by sewing. Stitchery is often added for further surface decoration.

Owing to the decaying nature of fabric, relatively few examples of *appliqué* have remained intact. Although primitive civilizations and cultures probably used this technique for decorating garments, some of the best surviving examples are those from the Middle Ages, when applied work was a cheaper substitute for embroidery and tapestry and was used for ecclesiastical, domestic and heraldic work. Later, in the sixteenth and seventeenth centuries, applied silks, velvets, damasks and woven brocades were mainly used for altar frontals, vestments and secular hangings.

The delicate linear patterns of the rococo period were quite unsuitable for this technique, but it still continued as a peasant art in countries such as Hungary and Persia.

During the last two centuries, the making of patchwork quilts has become

a popular pastime, particularly in Great Britain and the United States. Geometric and floral patterns have been the main source of inspiration for the applied silks and cottons, cut out from scraps saved from cutting cloth or rescued from old dresses. The results of this thrifty craft are highly individual and beautiful in design.

Early in this century, Jessie Newberry and Ann Macbeth of the Glasgow School of Art, both pioneers in the design and teaching of embroidery, frequently used *appliqué* for their bold plant forms and geometric shapes.

Later, in the 1930s, Rebecca Crompton, another leading designer and teacher, introduced the use of *appliqué* upon several layers of transparent gauze, often decorated with dynamic lines of hand and machine embroidery.

Since the Second World War, fabric collage has rapidly gained in popularity, with the wide choice of colourful, textured fabrics and trimmings available in the shops and the manufacture of modern adhesives. Both individuals and societies have contributed to its development as a medium throughout all stages of education from the nursery

Study the range of fabrics and braids which have been used in this panel to suggest the textures of brick and stone and the patterns of wrought iron.

school to adult education. It is also well within the reach of anyone at home who wishes to create a picture or wall hanging with minimum expense.

Old dresses, suits, tablecloths and curtaining, to name but a few items, can be rescued from the rag-bag or tracked down at jumble or rummage sales. They can then be sorted and stored by colour or texture in plastic bags and transparent plastic containers. This is an excellent method of re-cycling materials and, if you become a regular 'rummager', good entertainment for a Saturday afternoon.

A further point in favour of this form of collage is that your working area need not necessarily be large, a table or clear floor space is sufficient, and the clearing up is quick, clean and dry.

Base

Fabric must be firm and non-stretching, such as hessian [burlap]—plain or paper-backed, sold in natural tones and shades of many colours. Heavy weight cotton, heavy weight denim, heavy weight and medium weight dress and furnishing fabrics in a plain weave, plain canvas, mattress ticking, cardboard, polystyrene, metal gauze and chicken wire (fabric may be sewn or partially pushed through these).

Equipment

Pair of large scissors for general cutting, small scissors for cutting details, pins,

Below *Lacy cut-outs and knitting tinted with coffee or tea assembled for this delicate still-life.*

Right *Cut-outs have been painted with dye to create a fantasy forest.*

needles, thread, pencil, rule, compasses, scrap paper for designing, shelf lining paper, greaseproof [waxed] or tracing paper, white cardboard for mounting some fabrics, a weight to hold the material in position while the adhesive dries, spatula for adhesive, orange sticks or toothpicks for gluing tiny pieces, iron and ironing board or a blanket folded several times.

Adhesive

PVA, latex cement, milliner's rubber solution.

Design

Careful cutting and gluing are the basic technical requirements, but, as in all forms of art, the design is of paramount importance. Too much emphasis on realism and three-dimensional effects will only result in frustration, for basically fabric collage involves working with colour, pattern, texture and shape and these are the properties which should be fully exploited. Optical experiments have revealed that we see colour a split second before we distinguish shapes and textures. Therefore, it is this aspect of design which will make the initial impact on the onlooker. For this reason, time spent on choosing a good colour scheme will not be wasted.

In general, it is better for the beginner to work with a limited number of colours in non-patterned fabrics. One colour in a range of textures, or one colour in a range of tones from light to dark, or two or three shades of one colour, offer plenty of scope for variation within an overall unity. All black, all white or a mixture of the two with intermediate greys, can produce equally lively work. If you are short of a good selection of fabrics, why not dye all your odd pieces, including yarns and trimmings, in one colour? The resulting range and subtlety of tones will surprise you and could provide an excellent beginning for your collage.

Apart from colour, it is the tactile quality of the materials which should be

Left *Detail of a large collage depicting life in the small village of Charlbury in Oxfordshire, England. Note how the materials are used to suggest the textures of the actual surfaces. Perspective is forgotten and gives way to flat decoration.*
Right *This childlike collage illustrates the fairy tale—The Princess and the Pea.*

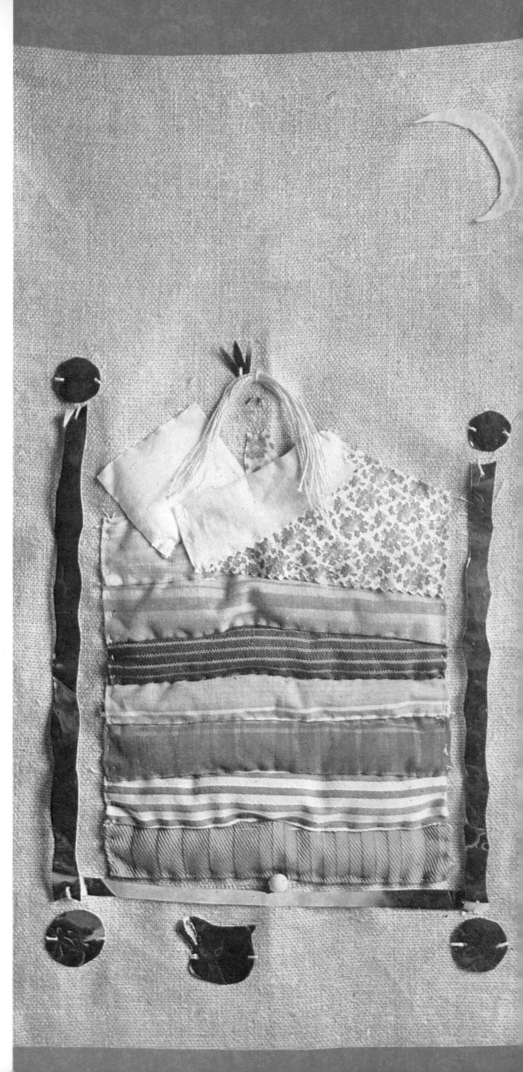

fully exploited, for they have a warmth and glow of their own which blend well with contemporary furnishings. Light plays a major role, for it is reflected or absorbed by the surface quality of the fabric. Shiny materials, such as satin, silk, taffeta, rayon, lurex and certain synthetics, reflect light, while others, such as felt, hessian [burlap] and woollen suiting, tend to absorb it.

Awareness of certain effects will give your work a particular mood. For example, herringbone tweed might suggest brickwork, scarlet silk, richness, and net and organdie, mistiness and mystery. In addition, it is well worth-while experimenting with the manipulative possibilities of the materials by padding, coiling, crumpling and treating them in a similar way to paper.

When designing, aim primarily for bold shapes, adding the smaller ones later. Remember that the background area is just as much part of the whole design as the applied shapes and usually it is a good plan to leave some spaces free of material as a visual 'breathing space' and a foil to detail. If you want unusual effects and contrasts, cut holes and glue other materials and surfaces behind the main fabric pieces.

To summarize: cut the large shapes first, adding the smaller ones later; try to keep the interest towards the middle, but not in the centre so that the design is not too symmetrical; remember that the background (negative) shapes are of equal importance; create variety in the proportion and spacing of the positive and negative shapes; balance the colours, shapes and tones; become aware of textures; try juxtaposing contrasting fabrics, such as shiny with matt.

Iron all your fabrics before working, applying, if required, iron-on backing materials to those which are likely to fray or show the glue marks. Velvet should be steamed.

After you have tacked out your working area, leaving at least a 5–8cm (2–3in) border for mounting, it is sometimes helpful to stretch your background fabric on to a board with drawing pins [thumb tacks]. Match the grain of the fabric to be applied with that of the background fabric, otherwise it may pucker when glued. Felt, PVC, leather, needlecord and light weight fabrics are the easiest for the

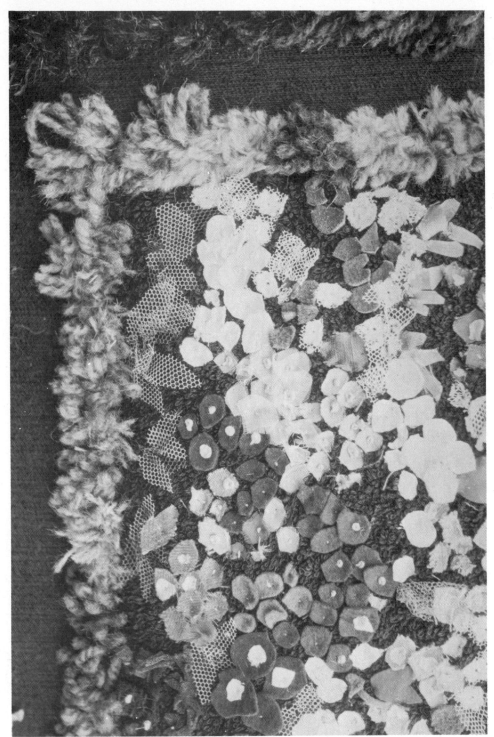

beginner to use.

There are four basic methods of cutting out the shapes for your design:

Cutting the shapes directly from the fabric. This method is spontaneous and well suited to collage.

Chalking or pencilling them directly on to the fabric before cutting.

Making paper patterns which are pinned on to the fabric and then cut around.

With a sharp point, tracing the design over dressmaker's carbon upon the fabric to be cut out. Care is needed

Above and above right Springtime *inspiration from a flower garden. Tiny pieces of fabric have been assembled to suggest a mass of flowers.*

as this leaves a permanent line.

Suggestions for experiment
Rag-bag

1 Collect odd scraps of fabric in tones of one colour—from light to dark—in shapes and textures which appeal to you. A good variation of texture is important and could range from silky and matt to rough and coarse. This will

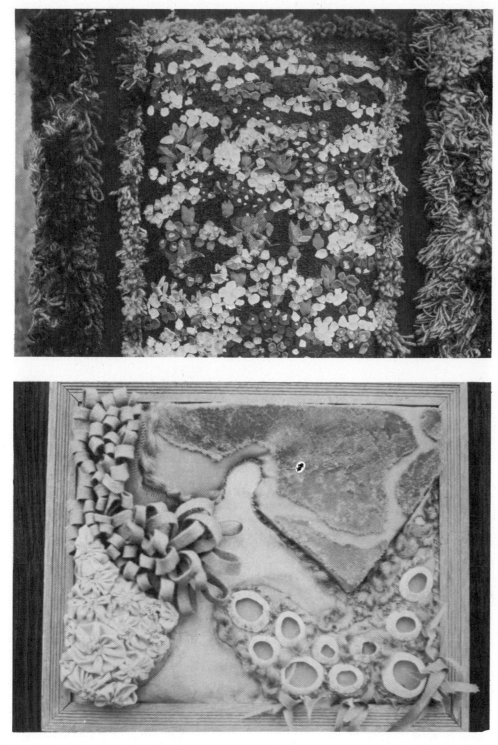

haphazardly.

4 Glue your fabrics to the background adding, if you wish, a small quantity of sequins, beads or buttons of a toning or contrasting colour, preferably off centre, to give your collage a focal point. Stitching could also be added, filling the shapes or following parts of their outline.

This initial exercise will improve your sense of colour, shape and texture, while you are exploring the intrinsic qualities of the materials.

Buildings

1 Make a quick drawing of the facade of your house or another building, or use a picture of one which attracts you. Churches, cathedrals and palaces also have many decorative possibilities. Avoid three-dimensional effects at this stage and aim for flat shapes and patterns.

2 Choose your fabrics in a small range of colours, but in varying textures. Some might suggest actual building materials such as tiles, bricks and stones. Iron the fabrics before cutting out.

3 Enlarge or trace the outlines of your building on to shelf lining or similar paper, keeping the shapes as simple as possible and seeing that they fill the major part of the background area.

4 Now either trace your design on to greaseproof [waxed] paper and cut up the shapes for your patterns, or cut up the drawing and use that as a pattern for the fabric.

5 Tack out the area in which you propose to work, leaving at least 5–8cm (2–3in) border for mounting purposes.

6 Place your fabric pieces in position on the background and move them around until you are satisfied with the balance of colours, tones and shapes.

7 Pin down and mark the position of each piece with pencil markings as a quick guide to positioning when you are gluing.

8 First glue the smaller and then the larger shapes with small quantities of thinly-spread adhesive. An orange stick or toothpick can be used for the tiny pieces. In the case of net, it is best to glue the background fabric first and then apply the net to it, pressing it down with a weight until it adheres.

9 Details, such as trees, flowers and figures can now be added if wished.

Above *A well-worn leather chair seat was the starting point for this collage of a rock pool, its mottled surface suggesting the texture of rocks.*

give your collage a lively, tactile quality.

2 Tack out the area in which you propose to place your shapes, leaving at least 5cm (2in) border all round if you intend to mount the collage.

3 Set out your collection of fabrics and trimmings on your working surface. Look at the flat shapes carefully

and then arrange some small, medium and large sizes within your tacked area. Use the 'snipped out' spaces from the fabrics to create a background of satisfying negative shapes, for this area plays an equally important part in the total design.

Alternatively, you might like to try a random placing of shapes by throwing your chosen pieces on to your area until you arrive at a satisfactory composition.

Note: A few well placed shapes will look better than too many arranged

Above *Colours change according to their background. If you look carefully at this panel you can see it for yourself. It may suggest some ideas for tonal change in your own work.*
Right *Bold shapes based on simple everyday objects are a good source of design for any collage. Note how some of the shapes have been overlapped.*

Flower garden
1 Collect as many pictures of flowers and trees as you can. Gardening catalogues, magazines and postcards are good sources.
2 Decide on your colour scheme. This may be suggested by the flowers themselves, or alternatively, you could could depart from reality and choose a subtle, harmonious colour scheme.
3 Select your background fabric. This could blend or contrast in colour with your applied materials.
4 Tack out your working area, leaving a 5–8cm (2–3in) border all round for mounting.
5 Iron all materials.
6 If you feel able, cut directly from the fabric rather than making paper patterns, for this will give the collage spontaneity and vitality. Build up your

individual flower shapes into masses and make larger individual plants with detailed petals and leaves.

If depth of view is required, place larger and brighter flowers and trees in the foreground and the smaller, paler ones in the distance. Overlapping of shapes will suggest a feeling of mass, while layers of net will give hazy, muted effects with a great range of colours and tones.

Aim for richness of texture in fabrics and variety in their method of application. For example, some flimsy materials could be slightly crumpled or ruched before gluing down. Pieces of lace, yarn, buttons, beads and sequins could also be added to enhance the whole.

7 Move the shapes around until a satisfactory arrangement is reached,

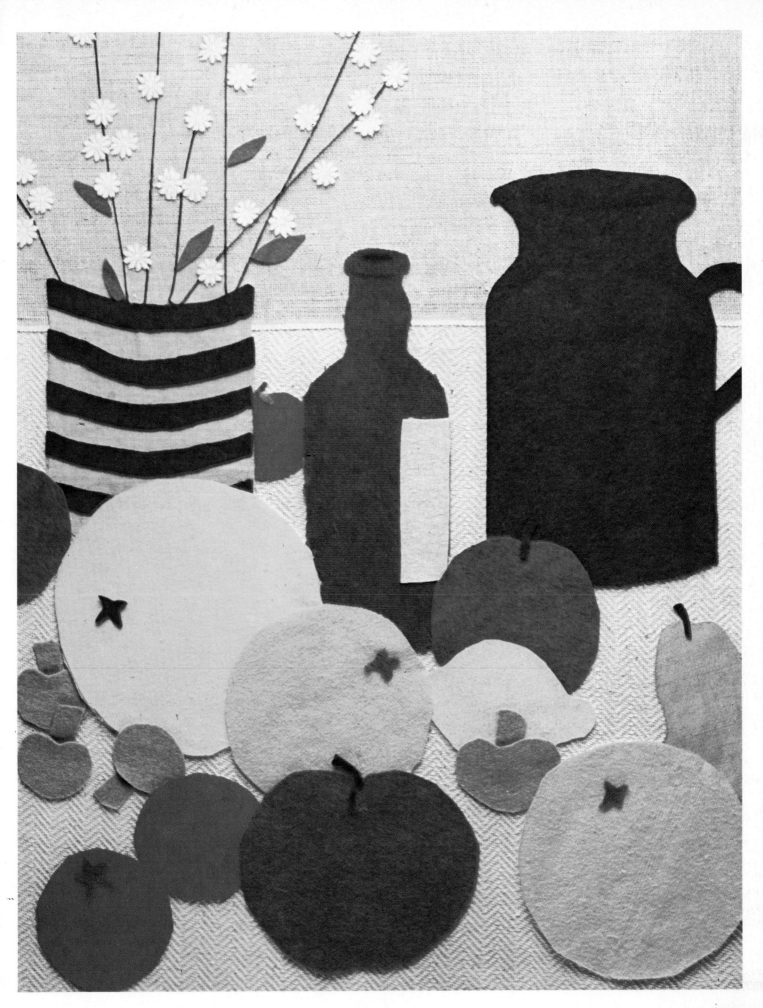

then glue down the materials, flower by flower, using tweezers and an orange stick or toothpick for gluing, where necessary.

Alternatively, you might like to compose your collage entirely of lace gathered from such things as old table mats and tablecloths, often thrown out for rummage sales. The delicate fretwork of the shapes lends itself well to flowers, leaves or trees, and if you wish, parts can be painted with pale water colours or cold water dyes before they are applied to the background.

It seems that the success of fabric collage lies in the choice of simple shapes. Children have a very direct approach to composing pictures with several shapes, treating them as flat decoration. For beginners, it is better to start with one shape, or a number of similar or related shapes. Bearing this in mind, here are some further ideas for development: fantastic birds, fish or insects such as butterflies, figures, faces and masks, uniforms, trees at different seasons, leaves, boats, bicycles, the elements—water, fire, ice, landscapes, aerial views, shadows, silhouettes, letters and numbers, still-life, bottles, view through a cardboard tube, autobiography, 'in memoriam'.

As you become more experienced, your powers of observation will increase, especially if you keep a sketch book close at hand for drawings of anything which inspires you, plus a scrapbook for pictures and notes. You will slowly discover what it is you really want to express and this may be the time to develop your work along a certain theme.

Padding areas of fabric
Fascinating and exciting three-dimensional effects can be achieved simply by padding.

Hard-edged method
The use of plastic or latex foam, or synthetic wadding is optional, according to the depth of padding required, but this method is especially suitable for hard-edged, geometric shapes.

1 Cut out your template from light weight or medium weight cardboard, such as cereal packets.

2 Lay your card template on the chosen fabric and draw round it with a pencil.

3 Cut out the fabric, leaving about 1cm (½in) or slightly less—according to

Printed fabrics have been combined with plain ones to give the impression of the richly patterned bedroom of the artist.

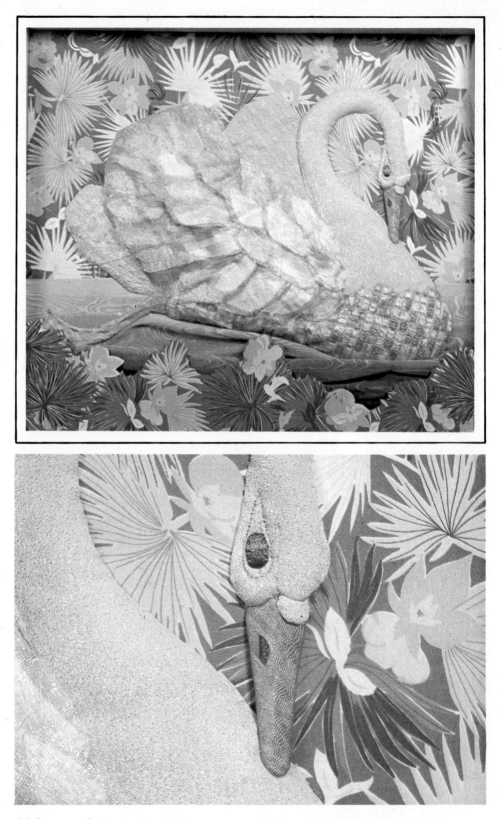

thickness and shape—for turnings.

4 Place the card shape on the wrong side of your fabric and neatly turn under the edges. If you want a more padded effect, cut your wadding or foam about ½cm (¼in) smaller than the finished shape and make a sandwich of the three layers. Where there are awkward curves, snip small, right-angled cuts in the turnings. This will ensure a hard edge

Above *Swan collage and a detail from it, showing the rich effects of the printed silk background, metallic fabric and soft-edged padding.*

Right *An abstract design taken from part of a natural object. Look at the way in which the flat felt shapes act as a contrast to the fine lines of stitchery. These, in turn, relate to the curves of the main shapes.*

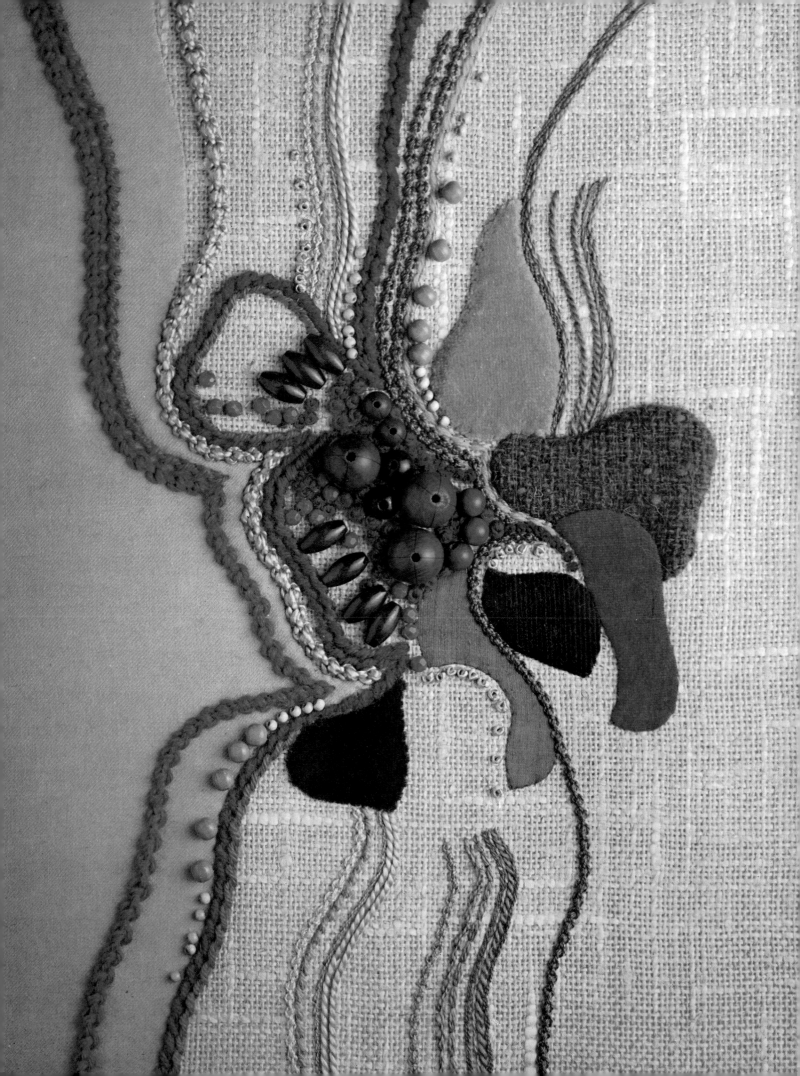

hand or machine stitching. Kapok, rather than cotton wool [absorbent cotton], is recommended for stuffing as the latter tends to go lumpy.

1 Mark out the area to be padded with tacking thread.

2 Cut your shape from a fabric which does not easily fray, such as felt. For an unusual shadow effect, you could use a clear plastic or transparent or semi-transparent fabric, such as net or organdie, and stuff your shape with brightly coloured wool, sequins, beads, crumpled silver or coloured foil.

3 Tack the shape to the background and then stitch it down firmly with either straight or zig-zag stitch on the sewing machine, or hand sew with buttonhole or chain stitch.

4 Turn the work over to the wrong side, and make a small slit in the centre of the shape to be padded.

5 Carefully push small quantities of kapok through the slit, using the end of a pencil or knitting needle, until the shape is firmly filled and springy to the touch. If you are padding transparent material, push beads, sequins etc. through the slit and finish padding with small quantities of kapok as required.

6 Stitch up the slit so that the stuffing cannot escape.

Stretching the finished collage

Providing the work is not too puckered, place the collage, face downwards, on to a blanket folded several times and press with a slightly dampened cloth or steam iron.

Should this be insufficient, the following method will solve the problem.

1 Find a wood or fibre board large enough to take the full size of the collage.

2 Cover the board with a slightly dampened cloth or three or four sheets of damped newspaper and blotting paper.

3 Place the collage, right side uppermost on the blotting paper. Pull out the longest sides of the work parallel with the board and secure each corner with a tack or pin. Place further tacks along the intervening space about 2.5-5 cm (1–2 in) apart.

4 Stretch the opposite edge and tack down in a similar manner.

5 Repeat with the remaining sides so that the corners are at right-angles.

6 Leave until the collage is completely dry—at least 24 hours or longer.

Previous page left *Texture plays a leading part in this collage to give the impression of the atmosphere of a heavy winter sky, the brickwork of the houses and the coat of the figure hurrying through the snow.*
Previous page right *Freely cut pieces of fabric stuck down and overlapped in parts to suggest foxgloves by a river.*

Above *Here fabrics are used to produce a subtle design of changing colours.*
Right *Based on the study of a fossil, this is an experiment in texture using fabric-covered polystyrene pieces for the focal point. Surface stitchery is in rug and knitting wool which contrasts with the fine linen threads used for the web-like design over the surface.*

and should eliminate puckering.

5 Glue down turnings with a small quantity of adhesive.

6 Finally, glue down the total shape— if necessary, catch down the edges on to the background fabric with small stitches.

Soft-edged method

This process involves a small amount of

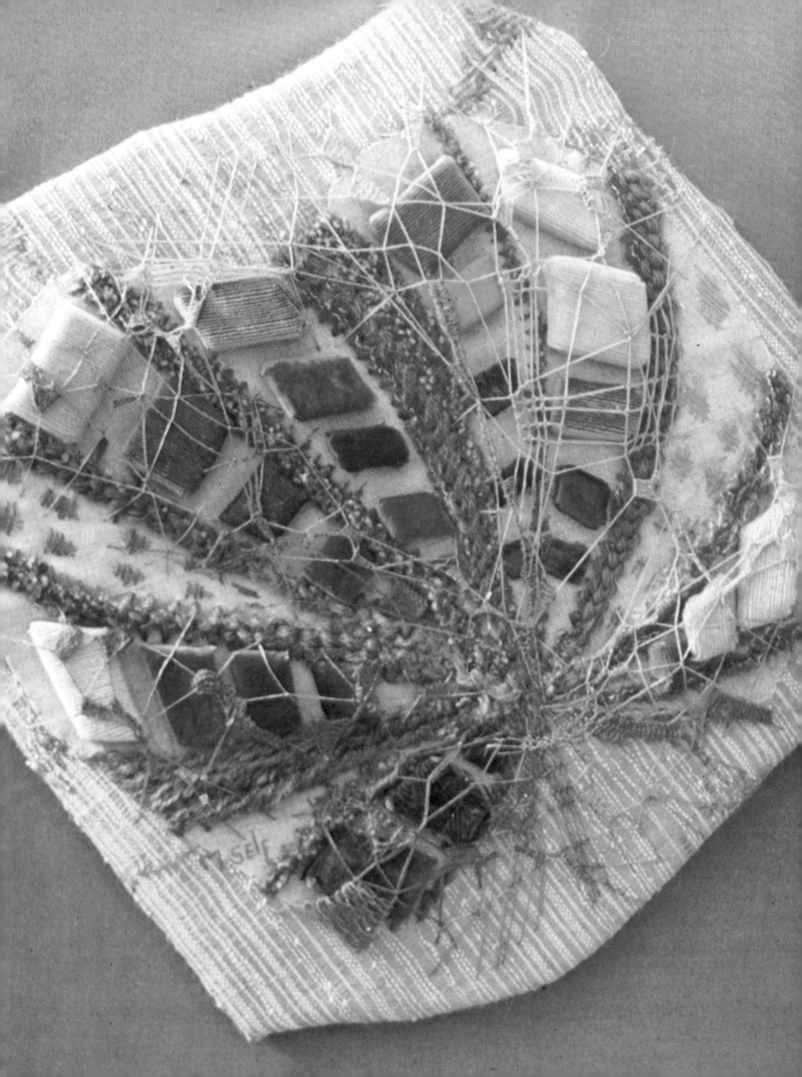

Fabrics chart

MATT		SHINY	
Plain	**Textured**	**Plain**	
Cottons and linens			
Calico		Chintz	
Cambric	Brushed cotton	Damask	
Canvas	Candlewick	Satin finish cotton [Cotton satin]	
Casement cloth	Chenille		
Denim	Corduroy [Wide wale corduroy]		
Duck	Embroidered cotton		
Gabardine	Flannelette		
Gingham	Huckaback		
Holland	Needlecord [Narrow wale corduroy]		
Lawn	Piqué		
Linen crash	Repp		
Madras	Scrim		
Poplin	Seersucker		
Sailcloth	Slub linen		
Sheeting [Percale]	Terry towelling [Terrycloth]		
Tailors' canvas	Twill weaves		
Ticking	Velvet [Velveteen]		
Wools and mixes			
Barathea	Angora	Broadcloth	
Crêpe	Blankets	Velour	
Felt	Bouclé		
Georgette	Knits		
Hopsack	Mohair		
Jersey	Ottoman		
Lightweight woollen fabric	Serge		
Twill weaves	Tweeds		
Welsh flannel			
Silks			
Georgette	Corded silk		
Grosgrain	Thai silk		
Foulard	Tussah/wild silk [Raw silk]		
Jap			
Moiré			
Satin			
Shantung			
Surah			
Taffeta			
Synthetics			
Celanese	Acrilan	Douppioni	
Dacron	Brushed nylon	Furnishing fabrics	
Linen-weave rayon	Fake fur	Lurex	
Orlon	Jersey	Polyester satin	
Rayon crash	Rayon tweed	PVC	
Rayon gabardine	Quilted nylon	Terylene lining	
Trevira	Velvet	Tricel [Tricocel]	

Materials

Virtually any type of fabric or trimming may be used for collage if it suits your purpose. Apply glue sparingly as it will tend to seep through many fabrics and avoid heavily patterned designs.

Trimmings		
Buttons	Leather	Fringing
Beads	Suede	Tape
Sequins	Jute	Curtain rings
Hemp	Cord	Sequin waste
Braid	Shoe laces	Feathers
Ribbon	Thonging	Fur

TRANSPARENT or SEMI-TRANSPARENT

Textured	Plain	Textured
	Batiste Cheesecloth Muslin Organdie [Organdy] Tarlatan Voile	Lace Net Spot muslin [Dotted Swiss muslin] Vegetable netting
		Crêpe de chine Chiffon Net
Fake fleece	Chiffon Organdie [Organdy] Nylon organza Nylon net Nylon crêpe Tights [Panty hose] Polythene [Plastic sheeting]	Lace Net curtaining Plastic fruit nets [Plastic mesh]

Kitchen things

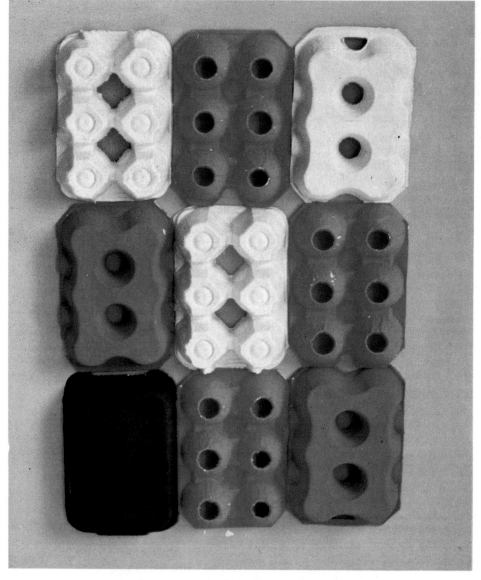

This chapter could be entitled 'collage for the housebound', as so many of the materials can be ransacked from drawers and cupboards and collected instead of being thrown away. If you wish to look further afield, rummage and jumble sales offer additional sources of culinary bric-a-brac.

Although these everyday objects are familiar, if you are to create a really original collage, it is necessary to look at them in a new light, seeing them in terms of shapes, colours and textures, rather than in their accepted setting. Have you ever stopped to study the mottled patterns of an old paint rag or the colourful range of plastic and metal bottle tops? Any of these articles could form part of a splendidly rich collage.

Materials
Used matches, cocktail sticks, toothpicks, lolly sticks, drinking straws, egg boxes, egg shells, aluminium foil containers and wrapping, milk bottle tops, plastic yogurt and margarine pots, bottle tops, lids, plastic and metal knives, forks, spoons, liquid soap dispensers, plastic bags, cardboard tubes, boxes, paper plates, cups, cake cases, absorbent kitchen towels, labels from cans and bottles, table cloths, broken china and glass, rubber gloves, nylon and metal scourers, wire wool, bristles from old scrubbing brushes, paint and polish rags (the older, the better), knitted dish cloths, net vegetable and fruit bags, clothes pegs [pins].

Base
This is dependent on the weight of the objects used in the collage. Cardboard, strawboard [insulating board], hardboard, plywood.

Equipment
Transparent containers for smaller items, old kitchen scissors, craft knife, glue spatula, tweezers for moving small objects, hand saw, shears, paint.

Adhesive
PVA, contact adhesive for heavier objects.

Design
This will inevitably be influenced by the assortment of shapes which you have managed to amass, but, as a general guideline, it is often better to limit yourself to objects of similar shapes rather than sticking down an amorphous collection and hoping that the composition will look right at a distance. A plan of some kind is essential, even if it is only radiating lines, a circular pattern, contrasting textures, all one colour objects or a collection of one type, such as can and bottle labels or cutlery.

Suggestions for experiment
Mobiles
Alexander Calder, the American sculptor and painter, invented the first mobiles in the early 1930s. Since then, they have become increasingly popular as a form

Various egg boxes used as repeating units and painted in bright colours, form this collage. Why not use this idea to cover a ceiling or wall, then spray paint in silver or one bright colour?

of kinetic art, casting moving patterns of light and shade on the surrounding surfaces of walls and ceilings.

Many of the objects found in the kitchen can be adapted whole or in part to create such mobiles. Both children and adults can make these decorations with minimal expense and much fun, especially at Christmas and Easter time.

Some forethought is necessary in collecting items, but friends and relatives can usually be persuaded to help in this respect. Apart from adhesive, a needle and sewing thread or nylon fishing line for suspending the moving objects and a pair of old kitchen scissors are virtually all that is required

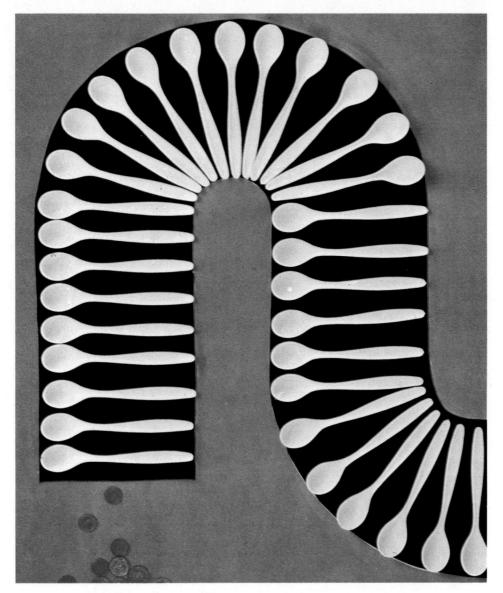

As with the egg boxes, only one type of object is used in this collage—plastic spoons arranged in a simple line and emphasized by a contrasting painted black stripe behind them.

in the way of equipment. Fairly thin but firm wire, a pea stick or bent wire coat hanger could provide the attachment for the separate parts.

Rather than give any specific instructions for the making of mobiles, here are a few ideas on construction which might encourage individual inventiveness. It is worth noting that aluminium foil combined with coloured foil wrappers from biscuits [cookies] and sweets [candies] is an ideal material for moulding around objects and reflecting light.

1 Foil containers and bottle tops 'fringed' into flowers or compressed into beads, then strung into groups with intervening straws.

2 Cylinders such as yogurt pots and cardboard tubes, sliced into different thicknesses, covered with foil and combined with coloured lids.

3 Egg cartons cut into separate cups, covered with foil or paint and regrouped to form bells or flower shapes.

4 Drinking straws cut into lengths and stuck, pinned or stapled together to form grids and stars. Lolly, match and cocktail sticks could be combined in a similar manner and, if you wish, sprayed with metallic lacquer or decorated with glitter dust.

If you intend to make a mobile composed of several parts, balancing the suspended objects is all important and will take a little time.

Consumer collage

Andy Warhol, the American pop artist, has immortalized Cambell's soups in his silk screen prints, transforming what is generally considered a mundane label into an object of beauty, by using subtle colours.

We generally take the designs on our packets and labels for granted, using them mainly for identification, but many are very well designed providing a colourful source of material. Why not save all the empty packets and labels and paste them down into a small kitchen collage, the cover of a book or, more ambitiously, on to a kitchen wall? A coat of PVA medium or varnish will help to seal the edges and protect the surface.

Plastic pot mosaic

Containers for margarine, yogurt and cream make ideal units for building up a three-dimensional mosaic. You may wish to use only one type of pot for a more unified appearance or alternatively, a variety of sizes could look quite exciting.

1 Arrange all your pots on a hardboard, plywood or clear plastic base. They could be set in rows, a circle or a random pattern.

2 Although there is no reason why the pots should not remain in their original form, cutting out the base with a craft knife or slicing off the tops at various levels, using an old pair of kitchen scissors, creates a livelier surface area with regular or irregular undulations according to your plan.

3 Decide upon your colour scheme. Here are a few ideas: all white, all one colour, black and white, tones of one colour from light to dark, strongly contrasting colours, complementary colours such as red and green, orange and blue, violet and yellow, metal foil—silver, gold or coloured.

There are several ways in which you might colour your pots. A base coat of white vinyl paint will give a matt surface for poster paint, or several coats of acrylic paint applied directly to the surface is also a satisfactory method. Spray lacquer can be applied to the complete panel at once and dries quickly. Aluminium and coloured foil, or brightly coloured yarn stuck down with a PVA adhesive could give a different finish.

Allow all parts, including the base, to dry thoroughly before applying glue.

Bottle tops, plastic and metal lids, foil containers, match boxes, cardboard tubes and egg boxes cut into separate units could be treated in a similar manner.

Mixed media

Mixed media, as its name implies, embraces every kind of material available and includes all the different art and craft techniques—drawing, painting, printing, engraving, tie dyeing, batik, embroidery. For this reason, the potential of collage is unique in its limitless scope for inventiveness.

Picasso was one of the first artists to recognize this fact, when in 1912 he incorporated into a small, oil painted still life, a fragment of cloth to simulate chair caning. Around this, in place of a frame, he coiled a length of rope. Since then, many well known artists have employed different media in their work. Kurt Schwitters is possibly one of the most outstanding, working in this way between 1914 and 1948. Initially, he was an academic portrait painter, but his vision extended beyond traditional materials and techniques into the rapidly developing world of the machine-made product and consumer society, where artifacts are discarded as soon as they have outlived their use or become un-unfashionable. Newspaper, postage stamps, worn-out shoe soles, train tickets, paint rags, sacking and string were a few of the items which replaced his palette and created a new reality in his expressive and evocative collages.

Following the examples of the Dadaist and surrealist artists, an American, Robert Rauschenberg, has, within the last 20 years, utilized the unexpected shock element in juxtaposing a strange miscellany of objects in his collages. He mixed oil paint on canvas with wood, paper, photographs, clock parts and, in one instance, a stuffed eagle.

Materials

Fabrics of any description, including trimmings, yarns and fibres, papers—plain, patterned and textured, photographs, magazines, newspapers, tickets, cardboard, metal, plastic, wooden, glass, china, rubber and polystyrene objects, natural objects, pencils, felt tip pens and markers, charcoal, chalk, pastels, wax crayons, candles, water colour, oil, tempera, poster, gouache, acrylic and powder paint, oil and water based printing inks, coloured inks, hot and cold water dyes, pastel dyeing crayons, plaster, clay, household paints, enamels, lacquers, varnishes, stains, wax polishes.

Base

This depends on the weight of the objects to be made into the collage. Refer to appropriate individual chapter.

Equipment

Refer to appropriate individual chapter.

Animated cosmology—a kinetic assemblage of found objects, motors, lights, castings and words.

Adhesive
Refer to appropriate individual chapter.

Design
Although the possibilities for mixed media in collage are endless, there is a danger of being carried away by such a wide range of materials and techniques, forgetting the importance of their relationships, in terms of colour, substance and texture, to the chosen theme. Selecting just the right media to express your idea requires considerable sensitivity and thought. For this reason, the experiments in this chapter are probably best left until some experience has been gained with a more limited range of media, otherwise the results may be disappointingly confused.

Suggestions for experiment
During this century there has been a rapid development of technology, growth in population and demand for education at all levels of society. There has, therefore, been a corresponding growth in visual communication. In urban life, especially, we are daily bombarded with pictures, words and symbols through the mass media in general. Noise acts as an anaesthetic in a world where our senses are assaulted by the machine.

It seems, therefore, all the more important that we should be aware of these deadening factors by cultivating within us a greater consciousness of our surroundings. Some of the following ideas will help us to do just this.

Snow and ice collage
No need to wait until the next snowfall —working out of doors is not essential. Poetry or music on this theme will be a useful aid.

1 Select your base which will be dependent upon the materials which you intend to use. Too small a surface could inhibit movement. Primed canvas, fabric stretched on a frame with staples or drawing pins [thumb tacks] or chicken wire are a few of the possibilities.
2 Arrange all your materials close at hand, as spontaneity is essential.
3 Now close your eyes and mentally project yourself into a snow world. Put down on a scrap of paper the feelings which immediately come to you—colours, textures, shapes, sensations on the skin and body, sounds and so on.

You may find it easier to begin your collage by painting the base with a large household brush to eliminate the awesome space quickly. Thin fabric, such as muslin, soaked in plaster or diluted PVA, then pressed down in wrinkles and folds, could also be a starting point. Alternatively, fabric and yarn poked through or sewn upon chicken wire might appeal to you. Acrylic paint is also a useful medium as you can stick objects such as crumpled polystyrene to it. Use anything which you feel is appropriate to the feeling you want to convey.

This approach to sensory communication could be explored in numerous ways, perhaps developing one idea or two contrasting sensations or working on a theme. The following list is by no means comprehensive but it may stimulate further thought.

External sensations
Sight—night, day, sunshine, rain, ice.
Sound—loud, soft, clang, clatter, thunder, buzz, hum, purr, rustle, gurgle, tinkle, sizzle, crackle, tap, rattle, music.
Touch—hard, soft, shiny, matt, coarse, smooth, stinging, prickling, tickling.
Taste—sweet, sour, spicy, savoury, sharp, musky, rancid, putrid.

Internal sensations
Fear, anger, hatred, violence, happiness, peace, love, tenderness.

Mounting

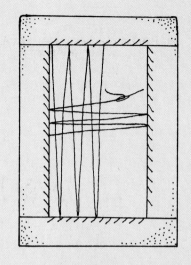

Fabric based collage
Method A

Even if you are inexperienced in wood-work, you should have no difficulty in mounting your finished work, assuming that the collage has four right-angled corners.

None of these methods includes glazing or framing, mainly because the tactile quality of collage is immediately lost when it is trapped under glass. Additionally, the choice of a correct frame is hazardous, often unnecessary and usually expensive. An occasional clean with a feather duster will generally preserve the work quite adequately.

Where some form of heavy protection is absolutely essential, for example, for tray and table tops, glass can be cut to size by your local hardware store. For the fragile items, such as pressed plants, a sheet of transparent adhesive vinyl plastic is easily applied and can be wiped clean with a damp cloth when necessary. For non-porous collages requiring a gloss finish, polyurethane varnish or PVA medium diluted with water, can be easily applied with a flat brush. Two thin coats are adequate for most materials, except wood. Immediately after use, soak the brushes in white spirit to remove polyurethane varnish, and in water to remove the PVA medium.

Fabric based collage

There are several ways of mounting this type of collage after it has been stretched or pressed to remove any puckering.
A By lacing fabric to hardboard with a strong thread.
B By tacking to a canvas stretcher with tacks or a staple gun.
C By gluing and tacking to hardboard backed with battens.
D By making a Japanese-type scroll with a pole or batten at the top and, if wished, at the bottom.

Methods B and C are also suitable for collages constructed upon bases made from chicken wire.

Method A
1 Using zig-zag stitch or oversewing, stitch the edges of the collage to prevent disintegration during the lacing.
2 Place the collage, wrong side upper-most, on a clean surface.
3 Take a piece of hardboard at least 7.5cm (3in) smaller than the outside edges of the collage and place it centrally on the fabric.
4 Thread a darning or chenille needle with a long length of carpet thread, thin string or twine. Knot the end and lace the fabric on to the hardboard, begin from the centres of the top and bottom, work to the sides. Join on more thread where necessary with a non-slipping knot. Occasionally turn the work over and check that the design is parallel with the edges. When each side is laced, pull from the centre to

the sides until the fabric is taut.
5 Repeat the process with the other opposite sides.
6 Neaten or mitre the corners with stitching in matching thread.

Method B
1 Assemble your canvas stretcher which should be at least 7.5cm (3in) smaller than the outside edges of your collage. These may be bought in a variety of sizes from any good art shop and considerable time and energy may be saved if the size is selected before commencing the collage.
2 Place the collage, wrong side upper-most, on a clean surface.
3 Stretch the fabric, smoothly and tautly, over the back of the stretcher and secure with drawing pins [thumb tacks] spaced about 2.5cm (1in) apart.
4 Replace each drawing pin [thumb tack], one at a time, with a staple or tack and then neaten the corners. This method helps to avoid errors, particularly on large panels.

Method C
1 Cut your hardboard at least 7.5cm (3in) shorter than your collage, checking that the corners are at right-angles.
2 Saw four lengths of batten wood to make a frame for the inside edge of the hardboard. No mitring is required, only an accurate butting together at the corners.
3 Stick down your prepared frame,

Method D

widest surface to the hardboard, with resin glue. Weight and leave for at least three hours.

4 Stretch your collage over the frame as in method B.

Method D

On a larger scale this method could be used for a room divider with a design on both sides of the fabric, or worked on semi-transparent material.

1 Cut an interlining of heavy weight fabric such as canvas, the same size as your finished collage. Check the accuracy of your measurements for lengths and angles.

2 Tack centre lines, vertically and horizontally through both collage and interlining.

3 Turn, press and pin down surplus fabric 5–7.5 cm (2–3 in) over the edges of the interlining. Glue down at edges and weight while drying.

4 Leaving a 0.6 cm ($\frac{1}{4}$ in) margin all the way round, stick down, at edges only, a lining fabric such as felt, which will not seep glue. Alternatively, slipstitch a piece of cotton sheeting or curtain lining.

5 Curtain rings or tabs may now be sewn on to the top edge and a length of dowelling or brass stair rod inserted.

If a coarse fabric such as hessian [burlap] is being used, it is not always necessary to turn under the edges. Instead, the sides may be left raw, the

Wood based collage

bottom fringed by withdrawing threads and these used for stitching an invisible hem on the topside to hold the pole. This method is particularly suitable for children.

Wood based collage

1 Smooth any rough edges with glass paper.

2 If a protective finish with a slight gloss is required, apply one or two coats of clear polyurethane varnish. Leave to dry overnight between coats.

3 Place panel face downwards and put in screw eyes about one third of the way down from the top edge.

Paper and cardboard based collage

If the paper or cardboard is buckled and the collaged surface is not raised, dampen the back with a sponge, weight and leave to dry.

Surface mounting

This involves taking a piece of flat board such as cardboard, hardboard or plywood and gluing the collage upon its surface, allowing for a margin of the 'ground' board to project around the outside of the work. This should be the same proportion as the collage and approximately one third larger in size. Generally the margins on the right and left sides are equal but the bottom one is usually slightly larger than the top.

1 Place the collage on the 'ground' board and mark each corner of the collage with the point of a sharp needle

Window mounting

or a pencil dot to note its position. A light pencil line may also be drawn around the edge.

2 Glue down with rubber solution—any excess may be smoothed away by the finger tip—or double sided adhesive tape.

Window mounting

This differs from surface mounting in that the collage is placed behind a piece of cardboard in which a window has previously been cut. The dimensions and proportions are similar to those used in surface mounting.

1 Place the collage on top of two pieces of cardboard of equal size and medium thickness.

2 Prick through both cards with a sharp needle at each corner, slightly inside to allow for overlap.

3 With the pricked marks for a guide, stick the collage to the first card.

4 Place the bottom card on a sheet of glass and join the pricked marks together with a thin, light pencil line. Add diagonal lines which will indicate corners when cutting.

5 Take a metal rule and, holding a sharp knife, such as a Stanley knife or craft knife, at an angle of 45 degrees inwards for a bevelled mount, cut out the pencilled shape.

6 For a permanent bond, secure the window to the mounted collage with two-sided adhesive tape or glue.

Further projects

This concluding chapter suggests further ways in which the medium may be developed for both large and small projects, which may be for personal or domestic use or purely for amusement. The ideas are roughly grouped under the heading of the base material on which the collage may be worked.

Fabric based collage

Cushions.

The bold effects which can be created by applied fabrics are well suited to decorating cushions. As the cover should be removable for cleaning, it is not advisable to use glue. Instead, sewing will hold the shapes down securely and quickly using either a zig-zag stitch on the raw edges or a straight stitch machined close to the turned edges. In both instances, it is important that the grain of the applied fabric matches that of the background. Note

Above Butterflies are an excellent source of design with their beautiful patterns and colours. Here, the shapes have been simplified and cut out in felt.
Right Collage is a good medium for children to use at Christmas time to depict the Nativity in friezes.

that the decoration is to be viewed from all angles. A hardwearing fabric such as heavy weight cotton or gabardine will make a good base. For a filling, in a separate bag, finely snipped nylon tights and stockings, kapok, poly beads, plastic foam and synthetic fibres are all suitable.

Table mats, cloths and aprons

PVC coated fabric is now available in a good range of colours. It is hard-wearing and may be cleaned with a dampened cloth. For a relatively small outlay, you could add decoration with

your own personal designs. Geometric or fruit shapes, letters or symbols could make simple cut-outs for application in plain or patterned PVC fabric of corresponding weight to the base. Affix with PVC adhesive or machine stitch—a special needle designed for this fabric will make the task easier.

Roller blinds

Roller blind kits may be bought fairly cheaply from some large furnishing stores and generally consist of a pole, bracket, tacks, screws, glue and wooden pull, but the fabric is not usually included. A plain canvas or cotton weave may be used. A border design of cotton patchwork shapes applied with zig-zag machine stitch could be suitable for decoration. Semi-transparent fabrics, such as net and organza, are best sewn on the back of the blind for muted shadow effects. Again, gluing has its disadvantages in that the shapes become unstuck at the edges with daily usage and the glue shows through the finer fabrics. When the roller blind is complete, fabric stiffener may be applied by a spray can.

Shoulder, shopping and beach bags

No special expertise is required for making a simple bag without gussets. The basic rectangular shape may be made of hessian [burlap], heavy weight cotton, PVC, canvas or towelling. Geometric patterns and letter shapes cut out of some non-fraying fabric, such as felt, PVC or suede can be stuck or sewn down.

Stitchery in coloured wools will help

Above *A selection of colourful silk patchwork cushions. Metal templates are used for accurate cutting out, of the paper patterns, then the fabric.*
Below *Soft sculpture for a* Country Seat, *using a collage of techniques on an old armchair—synthetics are used for the forests, hills and clouds and coloured tapes form the rainbow arm. Fantasy runs wild.*

disguise raw edges and enrich the design with linear patterns. Buttons, beads, coins, string and so on are further alternatives or additions to decoration. Matching coloured lining in cotton or towelling is essential for a good finish.

Paper and card based collage

Book covers

Text books, files and notebooks all provide a good base for paper collage using cut-outs from magazines, hand decorated papers or pressed flowers. The design is really dependent on the subject matter. In order to protect the collage, which is liable to peel or flake off, cover it with a sheet of transparent vinyl plastic obtainable from stationers or hardware stores. If this additional expense is not warranted, a coat or two of diluted PVA adhesive will act as a seal and give a slightly glossy finish. Labels for glass jars, bottles, children's rooms and so on could be treated in a similar manner.

Dice, counter and marble games

Children, as well as adults, can find using collage entertaining and instructive. With a little encouragement and help, they can invent their own games. Seeds, buttons or pasta can be used for counters, a yogurt pot for the shaker, cardboard egg trays, the side of a large cereal packet or packing case for the board. The rules should be written down on a piece of paper and then the board can be planned and decorated with felt tips pens, paint and collage.

Greetings cards

Cut paper shapes and patterns, seeds,

pressed plants, lace cut-outs, sequins and yarns are useful materials for making quick greetings and invitation cards. One simple motif, such as a star, patterned egg, letter or number, has greater visual impact, rather than a mixture of unrelated shapes. For extra Christmas sparkle, glitter dust, coloured foil and sequins are useful additions. Thin card, rather than paper, is generally the best base as it does not curl at the corners so readily.

Jewellery

Many children, including boys, enjoy making pendants, necklaces and arm bands. Papier mâché and paper strips cut from magazines are versatile and can be combined with seeds, beads and ring pulls from cans. The paper beads can then be painted with any water-based paint, then glazed with paper varnish or a few coats of diluted PVA medium.

Wood based collage

Collage may be applied to any well prepared wooden surface such as boxes and furniture—doors, cupboards, drawers, screens, chairs, stool tops, tables. Paper cut-outs are the most versatile form of decoration but care is needed in the correct choice of paper for lasting results. Second hand and children's books, old prints and engravings, greetings cards, postage stamps, tickets, magazines with heavy weight paper are possible sources from which small motifs, such as animals, flowers, insects or letters may be carefully cut out with small, sharp pointed scissors.

The general procedure is as follows:

1 Thoroughly rub down your object with medium weight glass paper to make it satin smooth, wiping off the dust as you work with a clean cloth.

2 Apply a white primer coat of paint with a flat paint brush, the size depending on the object. A water soluble paint, such as PVA, dries quickly and covers well. Alternatively, you may prefer a plain wood surface for your background. In this case, use clear polyurethane varnish.

3 When it is completely dry, lightly rub again with finer glass paper. If it

PVC is practical, stain-proof and virtually non-fraying when cut. This bright kitchen illustrates its use for aprons, table mats and a blind.

Far left *The ancient folk art of decorating eggs at Easter time is an enjoyable pastime for young and old alike. Remember to blow your eggs first and handle them carefully.*
Above and below *Home-made games from a collage of waste materials.*

is not completely dry, the paint will peel off.

4 Repeat the painting and rubbing process at least three or four times for a good finish. A work chart will help you remember each stage.

5 Select your cut-outs, preferably of the same thickness of paper, and arrange them on your surface. Stand away from your work from time to time to look at it. If in doubt, discard rather than add further motifs. Hold your design temporarily in place with a dot of rubber solution which can easily be rubbed off later.

6 Spread the glue evenly on the back of each cut-out with your finger, ensuring that the edges are well covered, then pat it down firmly on the wooden base to remove any air bubbles.

7 When thoroughly dry, apply a first coat of clear varnish with a clean brush. Leave in a warm place until it is completely dry—about 24 hours.

Previous page *Colourful masks can be made from papier mâché and children find them fun to make as well as to wear.*
Above *Boxes can be both original and amusing. Why not invent some more unusual shapes?*

8 Lightly rub the whole area with slightly dampened glass paper. If the cut-outs are fairly thick, two or three coats of varnish may be necessary before rubbing.

9 Repeat the rubbing and varnishing process approximately ten or more times for a really excellent finish. Several thin coats are preferable to a couple of thick ones.

Glass and perspex based collages

For stained glass window effects, broken bottles, semi-tranparent offcuts and pressed plants may be secured to a sheet of glass or perspex. For the heavier items, it is advisable to use a clear epoxy adhesive which is packaged in two components, the resin and the catalyst or hardener. For economy, mix only small quantities at a time in a foil lid. Finished collages require about a week in a warm place before they are hung over a window or other light source.

Murals

Following in the steps of Hans Christian Andersen and his *découpage* folding screen, a contemporary mural is fun to make and imparts individuality to any room. A wall of a child's room or a school corridor provide splendid opportunities to work on a larger scale, either as an individual or as a group. However, it is important that the surface should be in good condition, absolutely dry and not too porous.

Begin by coating the whole surface with white ploymer-acrylic primer or size. When dry, spread small areas of the wall with adhesive and stick down your collage materials, beginning at the bottom and working upwards. This allows for the slightly downward slide of the object.

Pictures, photographs, broken glass and ceramics plus any of the materials

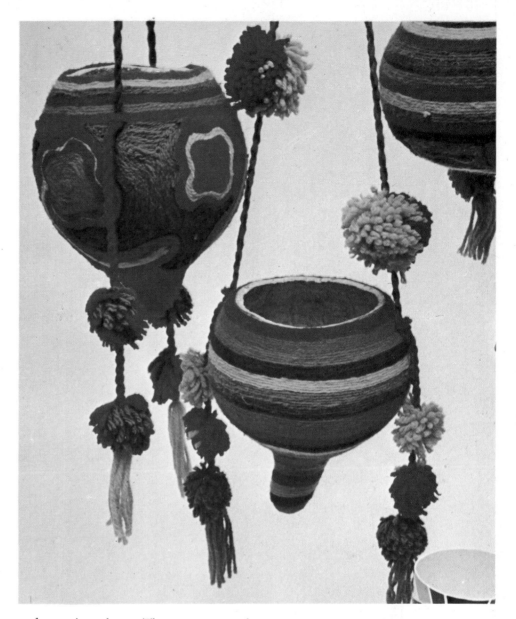

already suggested in this book are suitable for this mosaic collage. Wallpaper paste for paper and tile cement for the other items which are not too heavy, are good basic adhesives.

Masks

The significance of masks has largely been forgotten in the Western world, although they are still worn in the United States and many European countries for disguise in drama and carnivals. But in numerous places, such as Africa, the mask still plays an important part in tradition and religion.

Due mainly to the influence of Picasso and the Cubist movement, primitive art objects are widely accepted and appreciated today for their strength of form and richness of pattern. Such work may inspire you to make masks as attractive decorations.

They are not difficult to construct and children above all will enjoy creating and wearing them. There are several methods of making a base—a cardboard box, piece of fabric, paper bag or a balloon are satisfactory—but a more durable form may be moulded with clay, plasticine or chicken wire and built up with paper mâché. Coarser mesh chicken wire is required for larger masks and is left embedded in the papier mâché.

Materials

Clay, plasticine, chicken wire, board for clay and plasticine, petroleum jelly, newspaper, lining paper, wallpaper or flour and water paste, glue brush.

1 Mould the head from plasticine or clay set on the board. Check that the basic thickness is at least 2.5cm (1in).
2 Add features, exaggerating their size and shape.
3 Cover mould with petroleum jelly to prevent the papier mâché from sticking to it.

Plastic bottles and pots need not be thrown away. They can be transformed into attractive plant holders or pencil containers. The only requirements are yarn is a variety of bright colours, glue, scissors, including an old pair for cutting up the bottles, and patience.

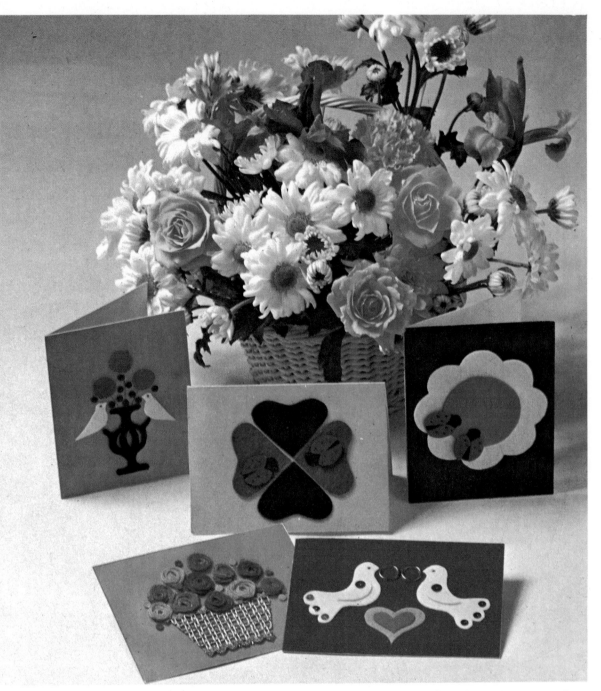

4 Tear off pieces of newspaper about 5cm (2in) square or in narrow strips. Dabble or brush them with glue until they are soft. Press on to the mould, smoothing down any rough edges.

5 Continue doing this until you have built up an overall thickness of about 0.3cm ($\frac{1}{8}$in). Alternating newspaper with lining paper allows you to see when each layer is complete. The final layer should be lining paper. At this stage, holes should be pierced in the mask for the later insertion of laces, sewing of fabric and so on.

6 Leave the mask to dry in a warm place for two to three days.

7 Remove clay or plasticine, leaving the now hardened shell of papier mâché.

8 Sandpaper if necessary, paint and decorate with yarn, string, raffia, seeds, shells and so on.

Further suggestions

Domestic

Book covers for cookery, address books etc., bottles, boxes—wood and card, candles, ceramic tiles, cupboards, cushions, deck chairs, doors, furniture, glass jars for pencils, sweets [candies] etc., lampshades, memo boards, mirrors, mobiles, murals, plant pots, roller blinds, room dividers, table and glass mats, tray and table tops, wall hangings and panels, waste paper bins.

Personal

Badges, beach, shopping and shoulder bags, belts, hats, jewellery.

Greetings cards are becoming increasingly expensive to buy, so why not make your own —they will bring much more pleasure to your relatives and friends. Keep to bold and simple dsigns.

Miscellaneous

Calendars, children's games, dolls' houses and furniture, fancy dress—headgear, masks, robes, kites, labels for objects and rooms, posters, scrapbooks, teaching aids for reading and mathematics.

Festivals

Greetings cards for all occasions—Easter, Christmas, St Valentine's Day, Easter eggs, Christmas decorations, invitation cards.

Designers

Eugenie Alexander 83; Janet Allen 35; Natalie d'Arbeloff endpapers, 58/9 courtesy Studio Vista, 90/1; Elizabeth Ashurst 74; Joanna Ball 42T; Laura Balston 1, 4/5, 15, 77, 82; Alison Barrell 96B; E Battersea 48T; Francis Carr 64; Stuart Dalby 2/3, 44/5, 48B; Madge Eastwood 30B; Lynn Evans 38B; Shirley Farrow 32/3; Cyril Foster 55; Caroline Gash 17R; Juliet Glynn-Smith 67T; Frances Kay 72; Maggie Lambert 22L; Ronald Liquorice 43T; Pamela McDowal from 'Pressed flowers collage' courtesy Littlewood Press 26; Sue Murdoch 78/9; Cathy Roberts 75; Patricia Redding 'Street of Houses' 68/9; Marjorie Self 76; Eiran Short 80T, 80B; Evelyn Staff 17B; Anthony Wilson 29; James Withey 49; Pamela Woods 53B.

Acknowledgements

Albury Manor County Secondary School, Merstham 38B, 39, 43T; courtesy Arts Council/Bull's Head by Picasso 9R; Beta Pictures 94, 104; Camera Press 62/3, 65, 66, 88, 89, 95; Connoisseur Studio 12T, 12B; Private Collection / 'Hugh Gaitskell as a famous monster of Filmland' – Richard Hamilton 60B; Holman Hunt Infant School, King's Road, Chelsea 64; courtesy The Tate Gallery /'The Elephant Celebes' – Max Ernst 9L; Photo & Text 70, 71; Picturepoint 51; Rapho/ George Hall 8R; Redhill Teachers' Centre 54T, 67B; Scala 21B; Search Press 22BR, 22/3, 23R, 68/9; Surbiton Adult Education Centre 54B, 75; courtesy Tate Gallery/'L' Escargot' – Matisse 12B; courtesy Tate Gallery/ 'Towards a definite statement of the coming trends in menswear' – Richard Hamilton 60T; Tri Art 10.

Photographers

Elizabeth Ashurst 17B, 22L, 30B, 34, 38B, 39, 43T, 48T, 54T, 54B, 67B, 74, 75; Adele Baker 76; Mike Benson 38T, 52, 56/7, 84, 96B; Steve Bicknell 16/7, 25, 29, 78/9, 82, 103; Lester Bookbinder 61; Francis Carr 8L, 64; Alan Duns 28, 47; Melvin Gray 41; Peter Heinz 19T, 53, 99T; Michael Holford 50; Chris Lewis 20/1, 31, 32/3, 42T, 44/5, 49, 67T, 96T; Bill McLaughlin 42B, 98; Dick Miller 2/3, 15, 24, 37; Alisdair Ogilvie 17R, 43B, 55; Roger Phillips 1, 4/5, 48B; Pat Philpot 18; P. Pugh-Cooke 97; Ethne Reuss 23BL; Val Rhodes 14; John Ryan 77; Bruce Scott 7; Ted Sebley 58/9, 90/1, endpapers; Mary Seyd 13, 19B; Jessica Strang 46; Peter Watkins 11, 80; John Webb 9, 12B; James Wedge 56; Michael Wickham 30T; Liz Whiting 102/3.

Artwork

Ann Rees 92/3

Artists' Materials by Natalie d'Arbeloff